ALABASTER

 ALABASTER

© 2016 Alabaster Co.

All rights reserved.
No part of this publication may be reproduced, distributed or transmitted in any form or by any means, including photocopying or other electronic or mechanical method, without prior written permission of the editor, except in the case of brief quotations embodied in critical reviews and certain other noncommercial uses permitted by copyright law. For permission requests, please write to us.

Holy Bible, New Living Translation, copyright © 1996, 2004, 2015 by Tyndale House Foundation. Used by permission of Tyndale House Publishers, Inc. All rights reserved.

Printed in Canada

Contact
hello@alabasterco.com
www.alabasterco.com

Alabaster Co. The Bible Beautiful.
Visual imagery & thoughtful design integrated within the four Gospels.
Cultivating conversation between art, beauty, & faith.

Founded in 2016.

ARTIST INTRODUCTION

When thinking of Matthew, the Sermon on the Mount is often the first part of the text that comes to mind. Jesus offers a reimagined, upside down kingdom through his new teachings, one where everyone - regardless of social or financial status - is invited. This Kingdom not only offers a new morality, but it is also the continuation of a long line of ancestors - from Abraham to David - chosen by God.

Royalty was an immediate theme evident in Matthew. Jesus is the ruler of this upside down Kingdom and has been "given all authority in heaven and on earth" (Matthew 28). Blue and purple push forward our creative energies, as two colors historically associated with royalty. We use a crown motif for Jesus to further emphasize his authority.

While the Gospel of Mark was written first, Matthew is placed as the first book within the New Testament in our common Bibles. In our personal experience, Matthew thus becomes the beginning, the emergence and the first introduction to who Jesus is. Creatively, there is something about small, singular objects that bring beginnings to mind. While our images in Matthew are certainly diverse in scale, there is a heavy bias towards that which is small.

Our culture is constantly searching for the beginning. We are frenetically searching for 'the next thing' that will satisfy us. Yet in that hunt for fulfillment, what if the teachings Jesus offers here is the last beginning we long for? What if Jesus' upside down kingdom brings us the life we need? Here is The Gospel of Matthew.

Bryan Chung and Brian Chung

GOSPEL OF
MATTHEW

ALABASTER | GOSPEL OF MATTHEW

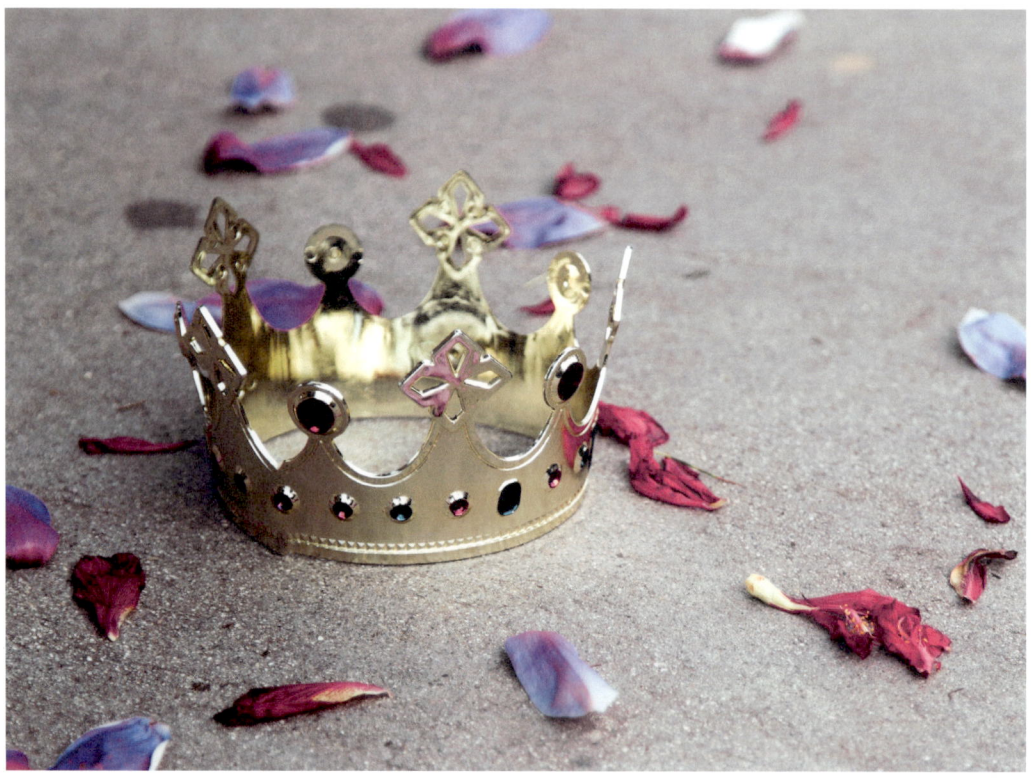

1

THE ANCESTORS OF JESUS THE MESSIAH

[1] This is a record of the ancestors of Jesus the Messiah, a descendant of David and of Abraham: [2] Abraham was the father of Isaac. Isaac was the father of Jacob. Jacob was the father of Judah and his brothers. [3] Judah was the father of Perez and Zerah (whose mother was Tamar). Perez was the father of Hezron. Hezron was the father of Ram. [4] Ram was the father of Amminadab. Amminadab was the father of Nahshon. Nahshon was the father of Salmon. [5] Salmon was the father of Boaz (whose mother was Rahab). Boaz was the father of Obed (whose mother was Ruth). Obed was the father of Jesse. [6] Jesse was the father of King David. David was the father of Solomon (whose mother was Bathsheba, the widow of Uriah). [7] Solomon was the father of Rehoboam. Rehoboam was the father of Abijah. Abijah was the father of Asa. [8] Asa was the father of Jehoshaphat. Jehoshaphat was the father of Jehoram. Jehoram was the father of Uzziah. [9] Uzziah was the father of Jotham. Jotham was the father of Ahaz. Ahaz was the father of Hezekiah. [10] Hezekiah was the father of Manasseh. Manasseh was the father of Amon. Amon was the father of Josiah. [11] Josiah was the father of Jehoiachin and his brothers (born at the time of the exile to Babylon). [12] After the Babylonian exile: Jehoiachin was the father of Shealtiel. Shealtiel was the father of Zerubbabel. [13] Zerubbabel was the father of Abiud. Abiud was the father of Eliakim. Eliakim was the father of Azor. [14] Azor was the father of Zadok. Zadok was the father of Akim. Akim was the father of Eliud. [15] Eliud was the father of Eleazar. Eleazar was the father of Matthan. Matthan was the father of Jacob. [16] Jacob was the father of Joseph, the husband of Mary. Mary gave birth to Jesus, who is called the Messiah. [17] All those listed above include fourteen generations from Abraham to David, fourteen from David to the Babylonian exile, and fourteen from the Babylonian exile to the Messiah.

THE BIRTH OF JESUS THE MESSIAH

[18] This is how Jesus the Messiah was born. His mother, Mary, was engaged to be married to Joseph. But before the marriage took place, while she was still a virgin, she became pregnant through the power of the Holy Spirit. [19] Joseph, to whom she was engaged, was a righteous man and did not want to disgrace her publicly, so he decided to break the engagement quietly. [20] As he considered this, an angel of the Lord appeared to him in a dream. "Joseph, son of David," the angel said, "do not be afraid to take Mary as your wife. For the child within her was conceived by the Holy Spirit. [21] And she will have a son, and you are to name him Jesus, for he will save his people from their sins." [22] All of this occurred to fulfill the Lord's message through his prophet: [23] "Look! The virgin will conceive a child! She will give birth to a son, and they will call him Immanuel, which means 'God is with us.'" [24] When Joseph woke up, he did as the angel of the Lord commanded and took Mary as his wife. [25] But he did not have sexual relations with her until her son was born. And Joseph named him Jesus.

2

VISITORS FROM THE EAST

[1] Jesus was born in Bethlehem in Judea, during the reign of King Herod. About that time some wise men from eastern lands arrived in Jerusalem, asking, [2] "Where is the newborn king of the Jews? We saw his star as it rose, and we have come to worship him." [3] King Herod was deeply disturbed when he heard this, as was everyone in Jerusalem. [4] He called a meeting of the leading priests and teachers of religious law and asked, "Where is the Messiah supposed to be born?" [5] "In Bethlehem in Judea," they said, "for this is what the prophet wrote: [6] 'And you, O Bethlehem in the land of Judah, are not least among the ruling cities of Judah, for a ruler will come from you who will be the shepherd for my people Israel.'" [7] Then Herod called for a private meeting with the wise men, and he learned from them the time when the star first appeared. [8] Then he told them, "Go to Bethlehem and search carefully for the child. And when you find him, come back and tell me so that I can go and worship him, too!" [9] After this interview the wise men went their way. And the star they had seen in the east guided them to Bethlehem. It went ahead of them and stopped over the place where the child was. [10] When they saw the star, they were filled with joy! [11] They entered the house and saw the child with his mother, Mary, and they bowed down and worshiped him. Then they opened their treasure chests and gave him gifts of gold, frankincense, and myrrh. [12] When it was time to leave, they returned to their own country by another route, for God had warned them in a dream not to return to Herod.

THE ESCAPE TO EGYPT

[13] After the wise men were gone, an angel of the Lord appeared to Joseph in a dream. "Get up! Flee to Egypt with the child and his mother," the angel said. "Stay there until I tell you to return, because Herod is going to search for the child to kill him." [14] That night Joseph left for Egypt with the child and Mary, his mother, [15] and they stayed there until Herod's death. This fulfilled what the Lord had spoken through the prophet: "I called my Son out of Egypt." [16] Herod was furious when he realized that the wise men had outwitted him. He sent soldiers to kill all the boys in and around Bethlehem who were two years old and under, based on the wise men's report of the star's first appearance. [17] Herod's brutal action fulfilled what God had spoken through the prophet Jeremiah: [18] "A cry was heard in Ramah— weeping and great mourning. Rachel weeps for her children, refusing to be comforted, for they are dead."

THE RETURN TO NAZARETH

[19] When Herod died, an angel of the Lord appeared in a dream to Joseph in Egypt. [20] "Get up!" the angel said. "Take the child and his mother back to the land of Israel, because those who were trying to kill the child are dead." [21] So Joseph got up and returned to the land of Israel with Jesus and his mother. [22] But when he learned that the new ruler of Judea was Herod's son Archelaus, he was afraid to go there. Then, after being warned in a dream, he left for the region of Galilee. [23] So the family went and lived in a town called Nazareth. This fulfilled what the prophets had said: "He will be called a Nazarene."

CHAPTER 2

3

JOHN THE BAPTIST PREPARES THE WAY

¹ In those days John the Baptist came to the Judean wilderness and began preaching. His message was, ² "Repent of your sins and turn to God, for the Kingdom of Heaven is near." ³ The prophet Isaiah was speaking about John when he said, "He is a voice shouting in the wilderness, 'Prepare the way for the Lord's coming! Clear the road for him!'" ⁴ John's clothes were woven from coarse camel hair, and he wore a leather belt around his waist. For food he ate locusts and wild honey. ⁵ People from Jerusalem and from all of Judea and all over the Jordan Valley went out to see and hear John. ⁶ And when they confessed their sins, he baptized them in the Jordan River. ⁷ But when he saw many Pharisees and Sadducees coming to watch him baptize, he denounced them. "You brood of snakes!" he exclaimed. "Who warned you to flee the coming wrath? ⁸ Prove by the way you live that you have repented of your sins and turned to God. ⁹ Don't just say to each other, 'We're safe, for we are descendants of Abraham.' That means nothing, for I tell you, God can create children of Abraham from these very stones. ¹⁰ Even now the ax of God's judgment is poised, ready to sever the roots of the trees. Yes, every tree that does not produce good fruit will be chopped down and thrown into the fire. ¹¹ "I baptize with water those who repent of their sins and turn to God. But someone is coming soon who is greater than I am—so much greater that I'm not worthy even to be his slave and carry his sandals. He will baptize you with the Holy Spirit and with fire. ¹² He is ready to separate the chaff from the wheat with his winnowing fork. Then he will clean up the threshing area, gathering the wheat into his barn but burning the chaff with never-ending fire."

THE BAPTISM OF JESUS

¹³ Then Jesus went from Galilee to the Jordan River to be baptized by John. ¹⁴ But John tried to talk him out of it. "I am the one who needs to be baptized by you," he said, "so why are you coming to me?" ¹⁵ But Jesus said, "It should be done, for we must carry out all that God requires." So John agreed to baptize him. ¹⁶ After his baptism, as Jesus came up out of the water, the heavens were opened and he saw the Spirit of God descending like a dove and settling on him. ¹⁷ And a voice from heaven said, "This is my dearly loved Son, who brings me great joy."

4

THE TEMPTATION OF JESUS

[1] Then Jesus was led by the Spirit into the wilderness to be tempted there by the devil. [2] For forty days and forty nights he fasted and became very hungry. [3] During that time the devil came and said to him, "If you are the Son of God, tell these stones to become loaves of bread." [4] But Jesus told him, "No! The Scriptures say, 'People do not live by bread alone, but by every word that comes from the mouth of God.'" [5] Then the devil took him to the holy city, Jerusalem, to the highest point of the Temple, [6] and said, "If you are the Son of God, jump off! For the Scriptures say, 'He will order his angels to protect you. And they will hold you up with their hands so you won't even hurt your foot on a stone.'" [7] Jesus responded, "The Scriptures also say, 'You must not test the Lord your God.'" [8] Next the devil took him to the peak of a very high mountain and showed him all the kingdoms of the world and their glory. [9] "I will give it all to you," he said, "if you will kneel down and worship me." [10] "Get out of here, Satan," Jesus told him. "For the Scriptures say, 'You must worship the Lord your God and serve only him.'" [11] Then the devil went away, and angels came and took care of Jesus.

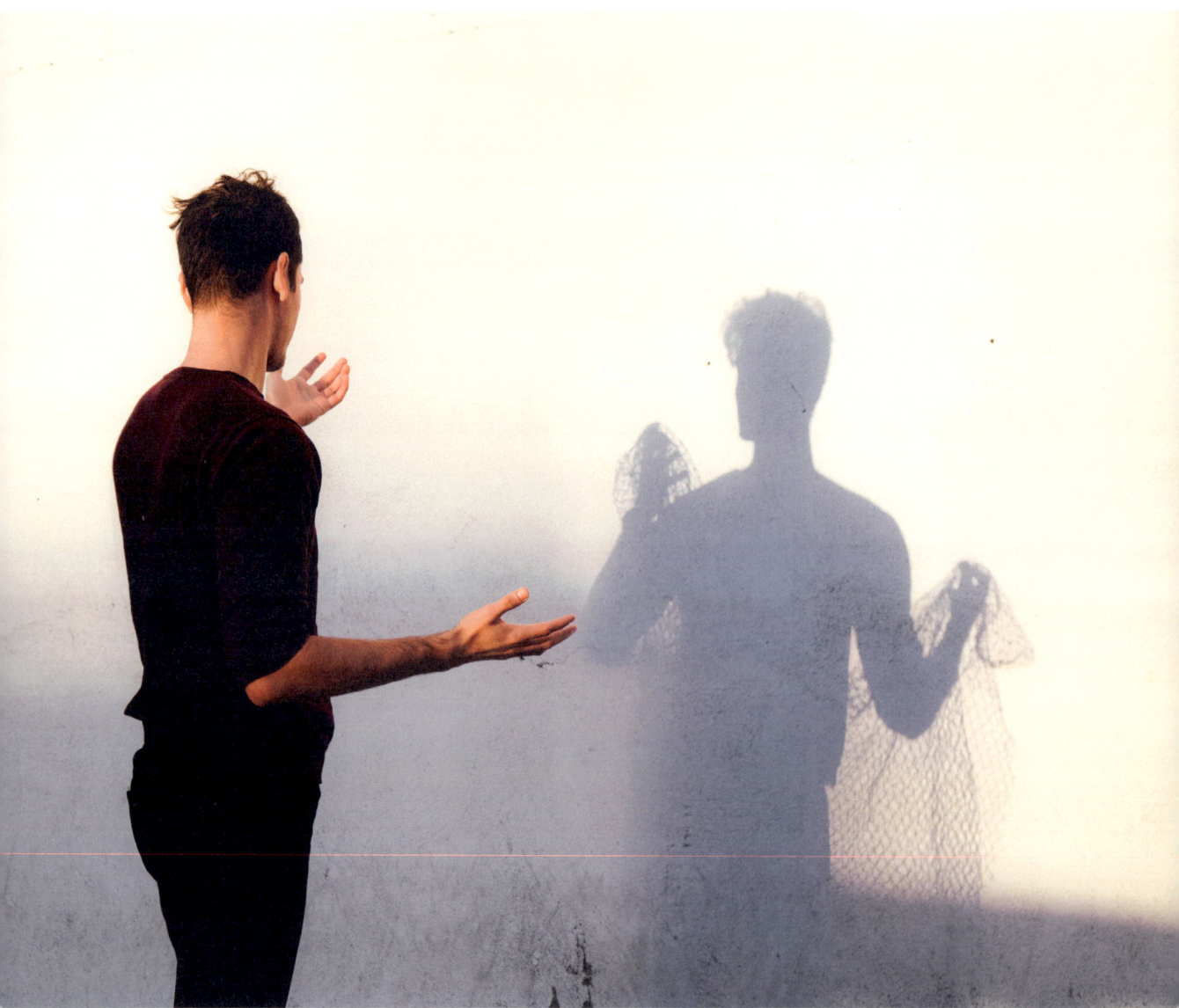

THE MINISTRY OF JESUS BEGINS

[12] When Jesus heard that John had been arrested, he left Judea and returned to Galilee. [13] He went first to Nazareth, then left there and moved to Capernaum, beside the Sea of Galilee, in the region of Zebulun and Naphtali. [14] This fulfilled what God said through the prophet Isaiah: [15] "In the land of Zebulun and of Naphtali, beside the sea, beyond the Jordan River, in Galilee where so many Gentiles live, [16] the people who sat in darkness have seen a great light. And for those who lived in the land where death casts its shadow, a light has shined." [17] From then on Jesus began to preach, "Repent of your sins and turn to God, for the Kingdom of Heaven is near."

THE FIRST DISCIPLES

[18] One day as Jesus was walking along the shore of the Sea of Galilee, he saw two brothers—Simon, also called Peter, and Andrew—throwing a net into the water, for they fished for a living. [19] Jesus called out to them, "Come, follow me, and I will show you how to fish for people!" [20] And they left their nets at once and followed him. [21] A little farther up the shore he saw two other brothers, James and John, sitting in a boat with their father, Zebedee, repairing their nets. And he called them to come, too. [22] They immediately followed him, leaving the boat and their father behind.

CROWDS FOLLOW JESUS

[23] Jesus traveled throughout the region of Galilee, teaching in the synagogues and announcing the Good News about the Kingdom. And he healed every kind of disease and illness. [24] News about him spread as far as Syria, and people soon began bringing to him all who were sick. And whatever their sickness or disease, or if they were demon possessed or epileptic or paralyzed—he healed them all. [25] Large crowds followed him wherever he went—people from Galilee, the Ten Towns, Jerusalem, from all over Judea, and from east of the Jordan River.

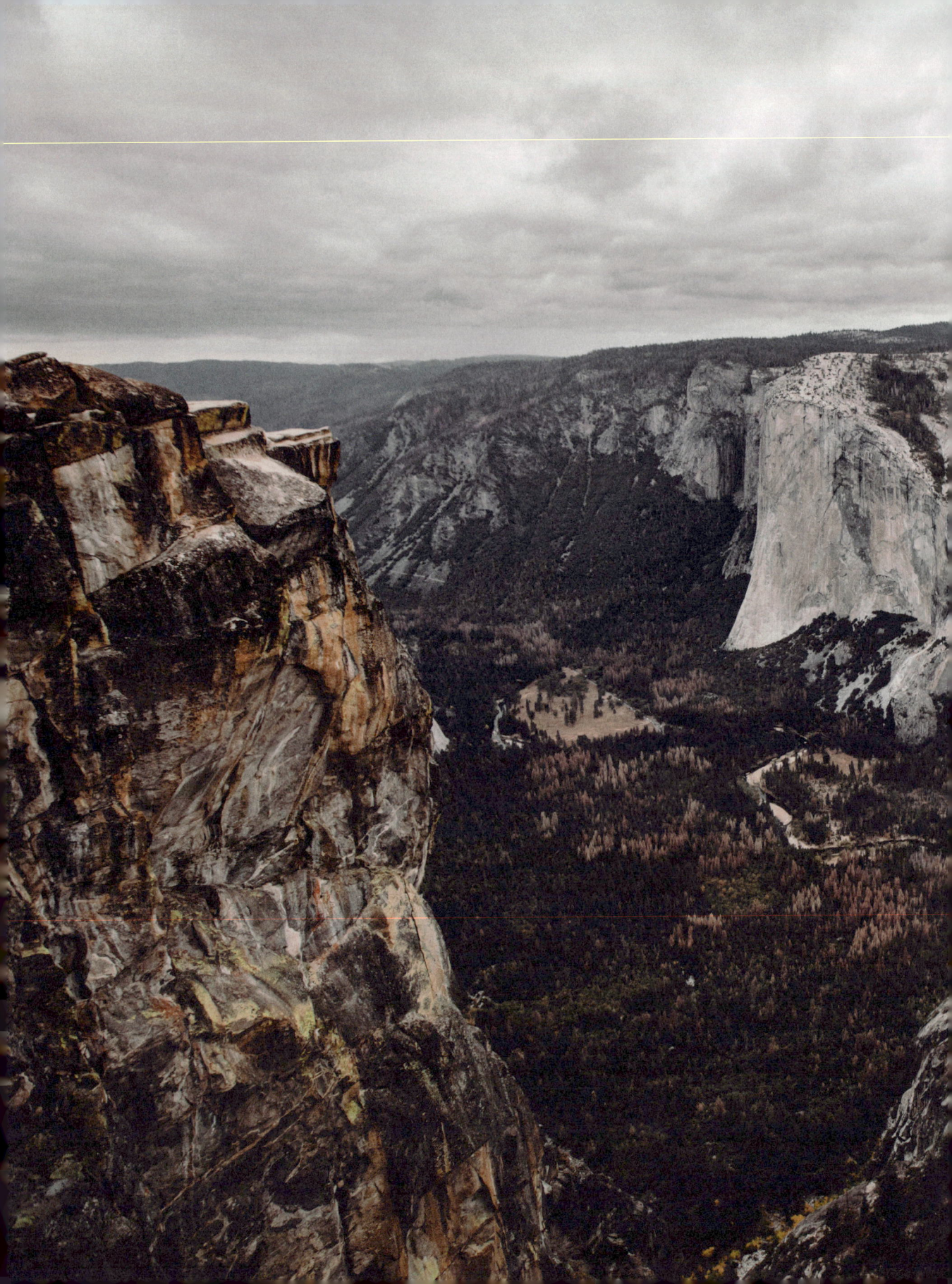

5

THE SERMON ON THE MOUNT

¹ One day as he saw the crowds gathering, Jesus went up on the mountainside and sat down. His disciples gathered around him, ² and he began to teach them.

THE BEATITUDES

³ "God blesses those who are poor and realize their need for him, for the Kingdom of Heaven is theirs. ⁴ God blesses those who mourn, for they will be comforted. ⁵ God blesses those who are humble, for they will inherit the whole earth. ⁶ God blesses those who hunger and thirst for justice, for they will be satisfied. ⁷ God blesses those who are merciful, for they will be shown mercy. ⁸ God blesses those whose hearts are pure, for they will see God. ⁹ God blesses those who work for peace, for they will be called the children of God. ¹⁰ God blesses those who are persecuted for doing right, for the Kingdom of Heaven is theirs. ¹¹ "God blesses you when people mock you and persecute you and lie about you and say all sorts of evil things against you because you are my followers. ¹² Be happy about it! Be very glad! For a great reward awaits you in heaven. And remember, the ancient prophets were persecuted in the same way.

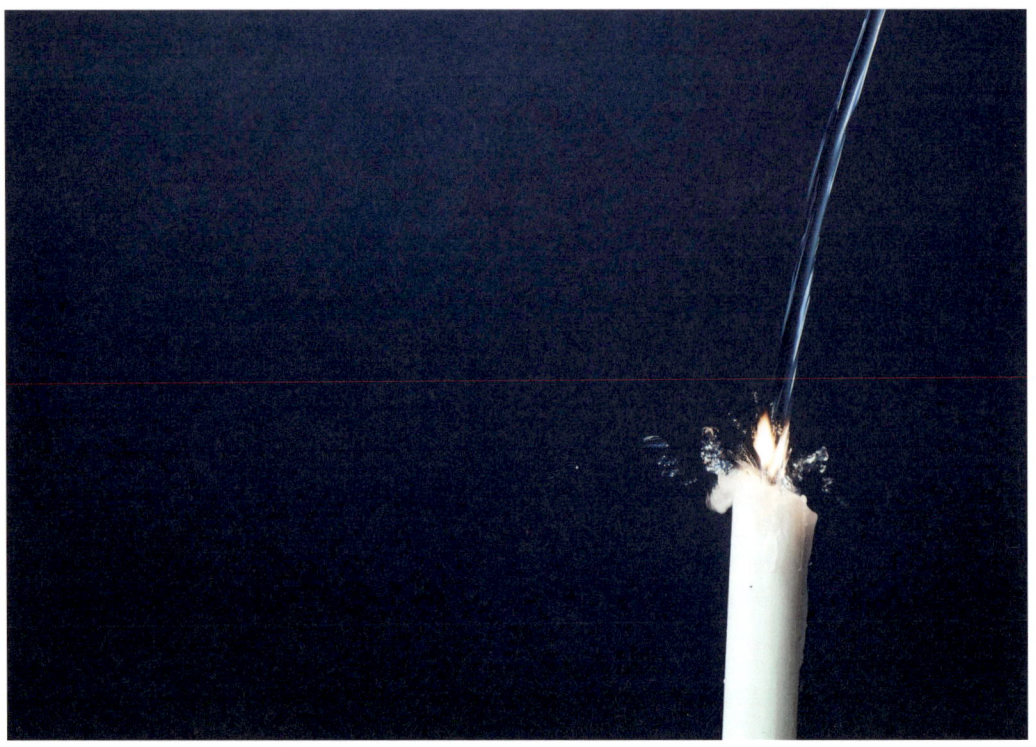

TEACHING ABOUT SALT AND LIGHT

¹³ "You are the salt of the earth. But what good is salt if it has lost its flavor? Can you make it salty again? It will be thrown out and trampled underfoot as worthless. ¹⁴ "You are the light of the world—like a city on a hilltop that cannot be hidden. ¹⁵ No one lights a lamp and then puts it under a basket. Instead, a lamp is placed on a stand, where it gives light to everyone in the house. ¹⁶ In the same way, let your good deeds shine out for all to see, so that everyone will praise your heavenly Father.

TEACHING ABOUT THE LAW

¹⁷ "Don't misunderstand why I have come. I did not come to abolish the law of Moses or the writings of the prophets. No, I came to accomplish their purpose. ¹⁸ I tell you the truth, until heaven and earth disappear, not even the smallest detail of God's law will disappear until its purpose is achieved. ¹⁹ So if you ignore the least commandment and teach others to do the same, you will be called the least in the Kingdom of Heaven. But anyone who obeys God's laws and teaches them will be called great in the Kingdom of Heaven. ²⁰ "But I warn you—unless your righteousness is better than the righteousness of the teachers of religious law and the Pharisees, you will never enter the Kingdom of Heaven!

TEACHING ABOUT ANGER

²¹ "You have heard that our ancestors were told, 'You must not murder. If you commit murder, you are subject to judgment.' ²² But I say, if you are even angry with someone, you are subject to judgment! If you call someone an idiot, you are in danger of being brought before the court. And if you curse someone, you are in danger of the fires of hell. ²³ "So if you are presenting a sacrifice at the altar in the Temple and you suddenly remember that someone has something against you, ²⁴ leave your sacrifice there at the altar. Go and be reconciled to that person. Then come and offer your sacrifice to God. ²⁵ "When you are on the way to court with your adversary, settle your differences quickly. Otherwise, your accuser may hand you over to the judge, who will hand you over to an officer, and you will be thrown into prison. ²⁶ And if that happens, you surely won't be free again until you have paid the last penny.

TEACHING ABOUT ADULTERY

²⁷ "You have heard the commandment that says, 'You must not commit adultery.' ²⁸ But I say, anyone who even looks at a woman with lust has already committed adultery with her in his heart. ²⁹ So if your eye—even your good eye—causes you to lust, gouge it out and throw it away. It is better for you to lose one part of your body than for your whole body to be thrown into hell. ³⁰ And if your hand—even your stronger hand—causes you to sin, cut it off and throw it away. It is better for you to lose one part of your body than for your whole body to be thrown into hell.

TEACHING ABOUT DIVORCE

³¹ "You have heard the law that says, 'A man can divorce his wife by merely giving her a written notice of divorce.' ³² But I say that a man who divorces his wife, unless she has been unfaithful, causes her to commit adultery. And anyone who marries a divorced woman also commits adultery.

TEACHING ABOUT VOWS

³³ "You have also heard that our ancestors were told, 'You must not break your vows; you must carry out the vows you make to the Lord.' ³⁴ But I say, do not make any vows! Do not say, 'By heaven!' because heaven is God's throne. ³⁵ And do not say, 'By the earth!' because the earth is his footstool. And do not say, 'By Jerusalem!' for Jerusalem is the city of the great King. ³⁶ Do not even say, 'By my head!' for you can't turn one hair white or black. ³⁷ Just say a simple, 'Yes, I will,' or 'No, I won't.' Anything beyond this is from the evil one.

TEACHING ABOUT REVENGE

³⁸ "You have heard the law that says the punishment must match the injury: 'An eye for an eye, and a tooth for a tooth.' ³⁹ But I say, do not resist an evil person! If someone slaps you on the right cheek, offer the other cheek also. ⁴⁰ If you are sued in court and your shirt is taken from you, give your coat, too. ⁴¹ If a soldier demands that you carry his gear for a mile, carry it two miles. ⁴² Give to those who ask, and don't turn away from those who want to borrow.

TEACHING ABOUT LOVE FOR ENEMIES

⁴³ "You have heard the law that says, 'Love your neighbor' and hate your enemy. ⁴⁴ But I say, love your enemies! Pray for those who persecute you! ⁴⁵ In that way, you will be acting as true children of your Father in heaven. For he gives his sunlight to both the evil and the good, and he sends rain on the just and the unjust alike. ⁴⁶ If you love only those who love you, what reward is there for that? Even corrupt tax collectors do that much. ⁴⁷ If you are kind only to your friends, how are you different from anyone else? Even pagans do that. ⁴⁸ But you are to be perfect, even as your Father in heaven is perfect.

CHAPTER 5

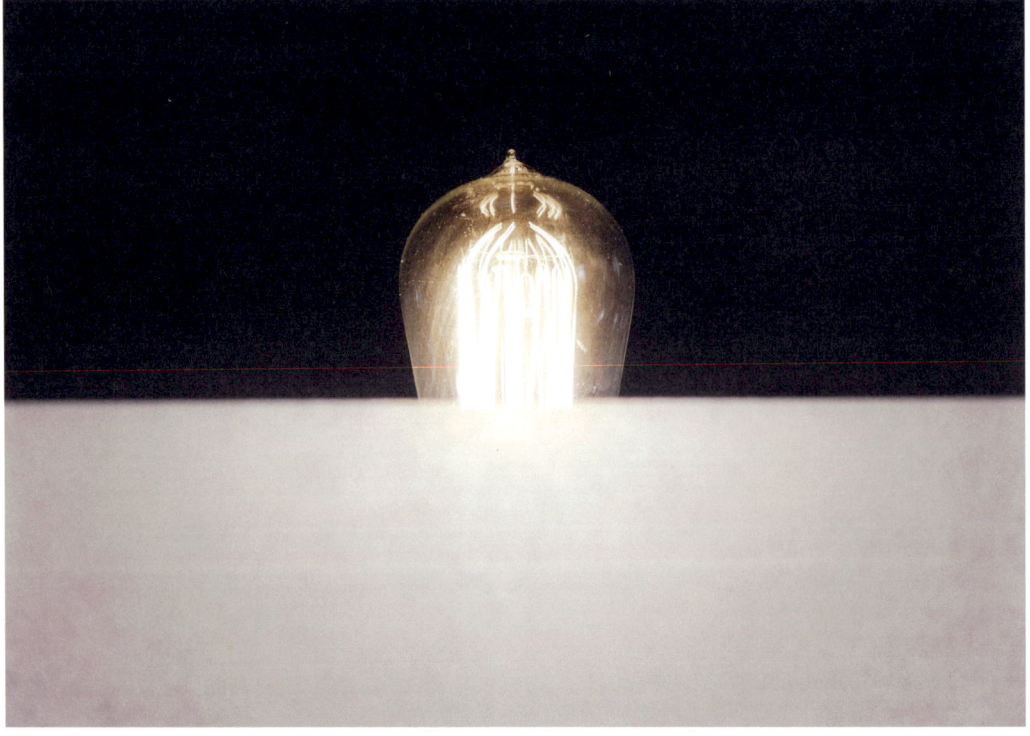

6

TEACHING ABOUT GIVING TO THE NEEDY

[1] "Watch out! Don't do your good deeds publicly, to be admired by others, for you will lose the reward from your Father in heaven. [2] When you give to someone in need, don't do as the hypocrites do—blowing trumpets in the synagogues and streets to call attention to their acts of charity! I tell you the truth, they have received all the reward they will ever get. [3] But when you give to someone in need, don't let your left hand know what your right hand is doing. [4] Give your gifts in private, and your Father, who sees everything, will reward you.

TEACHING ABOUT PRAYER AND FASTING

[5] "When you pray, don't be like the hypocrites who love to pray publicly on street corners and in the synagogues where everyone can see them. I tell you the truth, that is all the reward they will ever get. [6] But when you pray, go away by yourself, shut the door behind you, and pray to your Father in private. Then your Father, who sees everything, will reward you. [7] "When you pray, don't babble on and on as the Gentiles do. They think their prayers are answered merely by repeating their words again and again. [8] Don't be like them, for your Father knows exactly what you need even before you ask him! [9] Pray like this: Our Father in heaven, may your name be kept holy. [10] May your Kingdom come soon. May your will be done on earth, as it is in heaven. [11] Give us today the food we need, [12] and forgive us our sins, as we have forgiven those who sin against us. [13] And don't let us yield to temptation, but rescue us from the evil one. [14] "If you forgive those who sin against you, your heavenly Father will forgive you. [15] But if you refuse to forgive others, your Father will not forgive your sins. [16] "And when you fast, don't make it obvious, as the hypocrites do, for they try to look miserable and disheveled so people will admire them for their fasting. I tell you the truth, that is the only reward they will ever get. [17] But when you fast, comb your hair and wash your face. [18] Then no one will notice that you are fasting, except your Father, who knows what you do in private. And your Father, who sees everything, will reward you.

TEACHING ABOUT MONEY AND POSSESSIONS

[19] "Don't store up treasures here on earth, where moths eat them and rust destroys them, and where thieves break in and steal. [20] Store your treasures in heaven, where moths and rust cannot destroy, and thieves do not break in and steal. [21] Wherever your treasure is, there the desires of your heart will also be. [22] "Your eye is like a lamp that provides light for your body. When your eye is healthy, your whole body is filled with light. [23] But when your eye is unhealthy, your whole body is filled with darkness. And if the light you think you have is actually darkness, how deep that darkness is! [24] "No one can serve two masters. For you will hate one and love the other; you will be devoted to one and despise the other. You cannot serve God and be enslaved to money. [25] "That is why I tell you not to worry about everyday life—whether you have enough food and drink, or enough clothes to wear. Isn't life more than food, and your body more than clothing? [26] Look at the birds. They don't plant or harvest or store food in barns, for your heavenly Father feeds them. And aren't you far more valuable to him than they are? [27] Can all your worries add a single moment to your life? [28] "And why worry about your clothing? Look at the lilies of the field and how they grow. They don't work or make their clothing, [29] yet Solomon in all his glory was not dressed as beautifully as they are. [30] And if God cares so wonderfully for wildflowers that are here today and thrown into the fire tomorrow, he will certainly care for you. Why do you have so little faith? [31] "So don't worry about these things, saying, 'What will we eat? What will we drink? What will we wear?' [32] These things dominate the thoughts of unbelievers, but your heavenly Father already knows all your needs. [33] Seek the Kingdom of God above all else, and live righteously, and he will give you everything you need. [34] "So don't worry about tomorrow, for tomorrow will bring its own worries. Today's trouble is enough for today."

CHAPTER 6

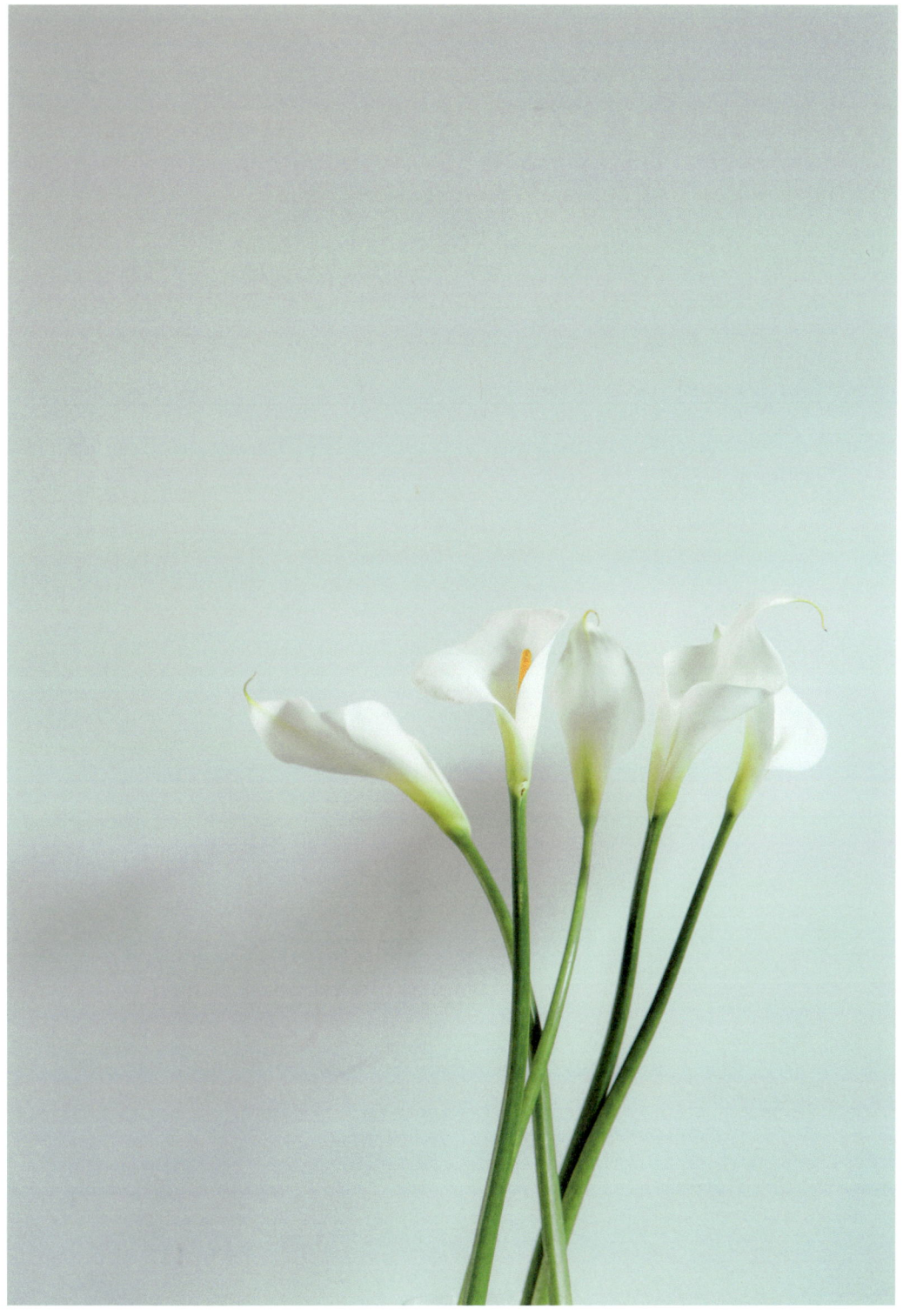

7

DO NOT JUDGE OTHERS

[1] "Do not judge others, and you will not be judged. [2] For you will be treated as you treat others. The standard you use in judging is the standard by which you will be judged. [3] "And why worry about a speck in your friend's eye when you have a log in your own? [4] How can you think of saying to your friend, 'Let me help you get rid of that speck in your eye,' when you can't see past the log in your own eye? [5] Hypocrite! First get rid of the log in your own eye; then you will see well enough to deal with the speck in your friend's eye. [6] "Don't waste what is holy on people who are unholy. Don't throw your pearls to pigs! They will trample the pearls, then turn and attack you.

EFFECTIVE PRAYER

[7] "Keep on asking, and you will receive what you ask for. Keep on seeking, and you will find. Keep on knocking, and the door will be opened to you. [8] For everyone who asks, receives. Everyone who seeks, finds. And to everyone who knocks, the door will be opened. [9] "You parents—if your children ask for a loaf of bread, do you give them a stone instead? [10] Or if they ask for a fish, do you give them a snake? Of course not! [11] So if you sinful people know how to give good gifts to your children, how much more will your heavenly Father give good gifts to those who ask him.

THE GOLDEN RULE

[12] "Do to others whatever you would like them to do to you. This is the essence of all that is taught in the law and the prophets.

CHAPTER 7

THE NARROW GATE

[13] "You can enter God's Kingdom only through the narrow gate. The highway to hell is broad, and its gate is wide for the many who choose that way. [14] But the gateway to life is very narrow and the road is difficult, and only a few ever find it.

THE TREE AND ITS FRUIT

[15] "Beware of false prophets who come disguised as harmless sheep but are really vicious wolves. [16] You can identify them by their fruit, that is, by the way they act. Can you pick grapes from thornbushes, or figs from thistles? [17] A good tree produces good fruit, and a bad tree produces bad fruit. [18] A good tree can't produce bad fruit, and a bad tree can't produce good fruit. [19] So every tree that does not produce good fruit is chopped down and thrown into the fire. [20] Yes, just as you can identify a tree by its fruit, so you can identify people by their actions.

TRUE DISCIPLES

[21] "Not everyone who calls out to me, 'Lord! Lord!' will enter the Kingdom of Heaven. Only those who actually do the will of my Father in heaven will enter. [22] On judgment day many will say to me, 'Lord! Lord! We prophesied in your name and cast out demons in your name and performed many miracles in your name.' [23] But I will reply, 'I never knew you. Get away from me, you who break God's laws.'

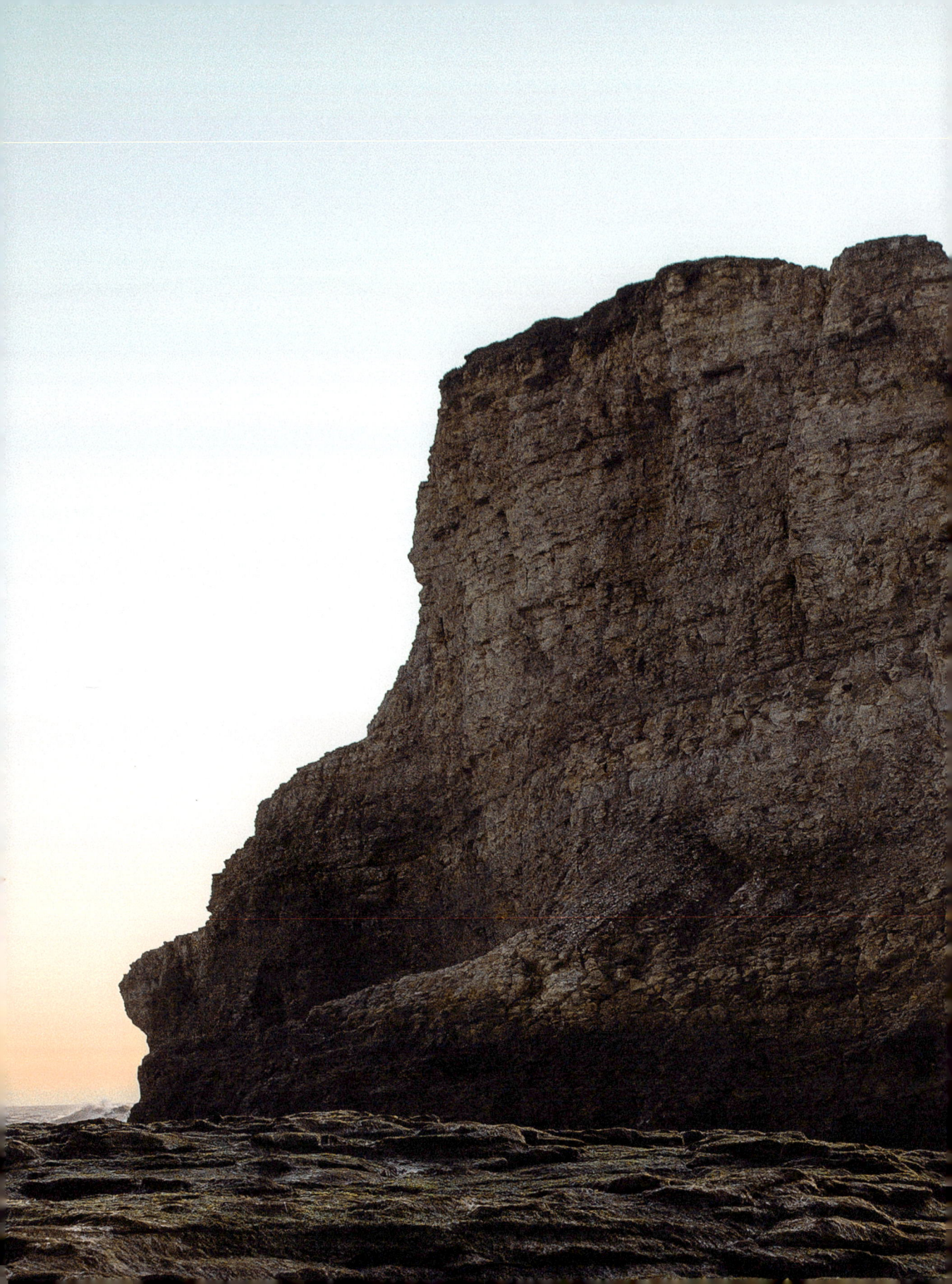

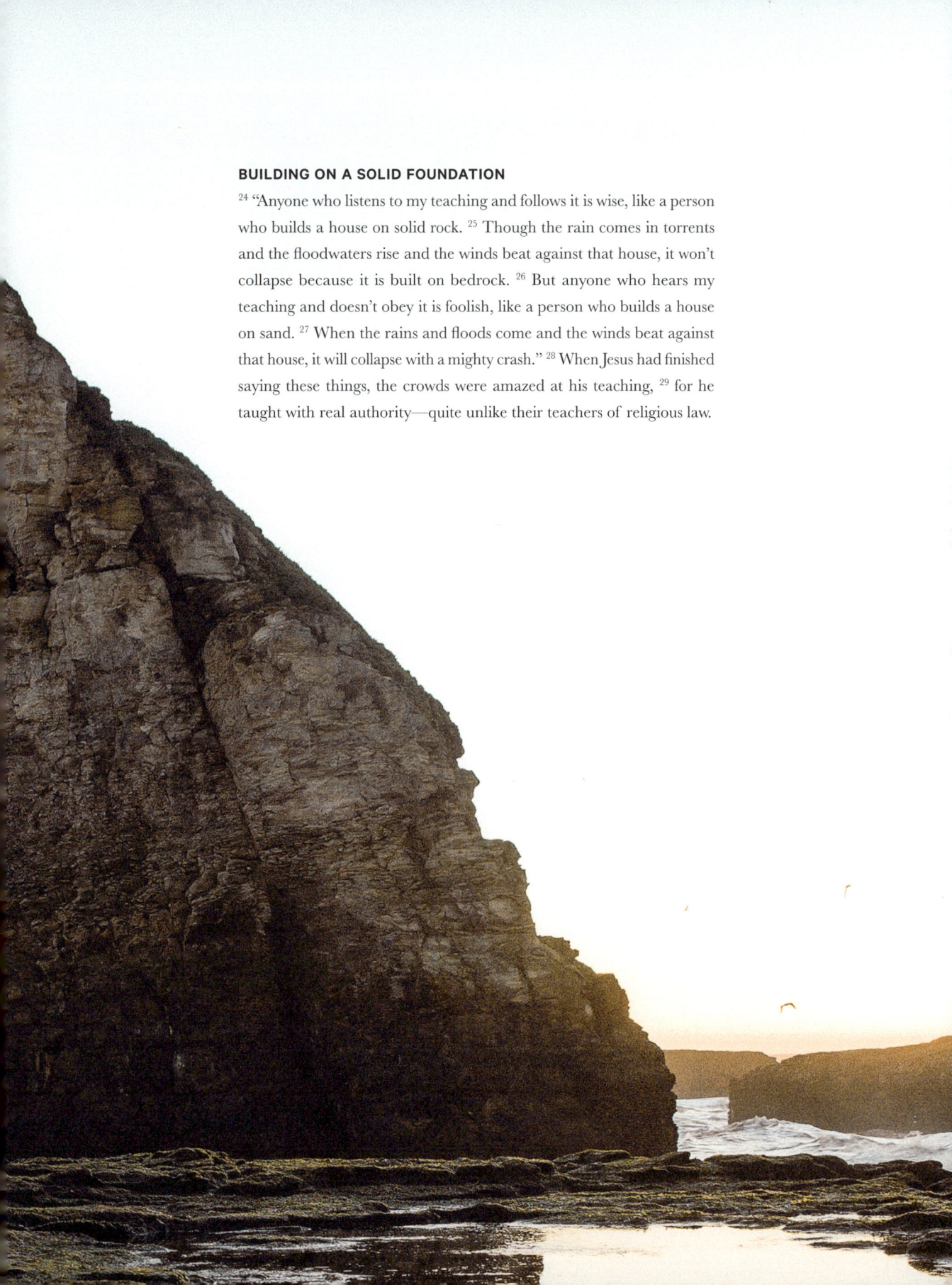

BUILDING ON A SOLID FOUNDATION

[24] "Anyone who listens to my teaching and follows it is wise, like a person who builds a house on solid rock. [25] Though the rain comes in torrents and the floodwaters rise and the winds beat against that house, it won't collapse because it is built on bedrock. [26] But anyone who hears my teaching and doesn't obey it is foolish, like a person who builds a house on sand. [27] When the rains and floods come and the winds beat against that house, it will collapse with a mighty crash." [28] When Jesus had finished saying these things, the crowds were amazed at his teaching, [29] for he taught with real authority—quite unlike their teachers of religious law.

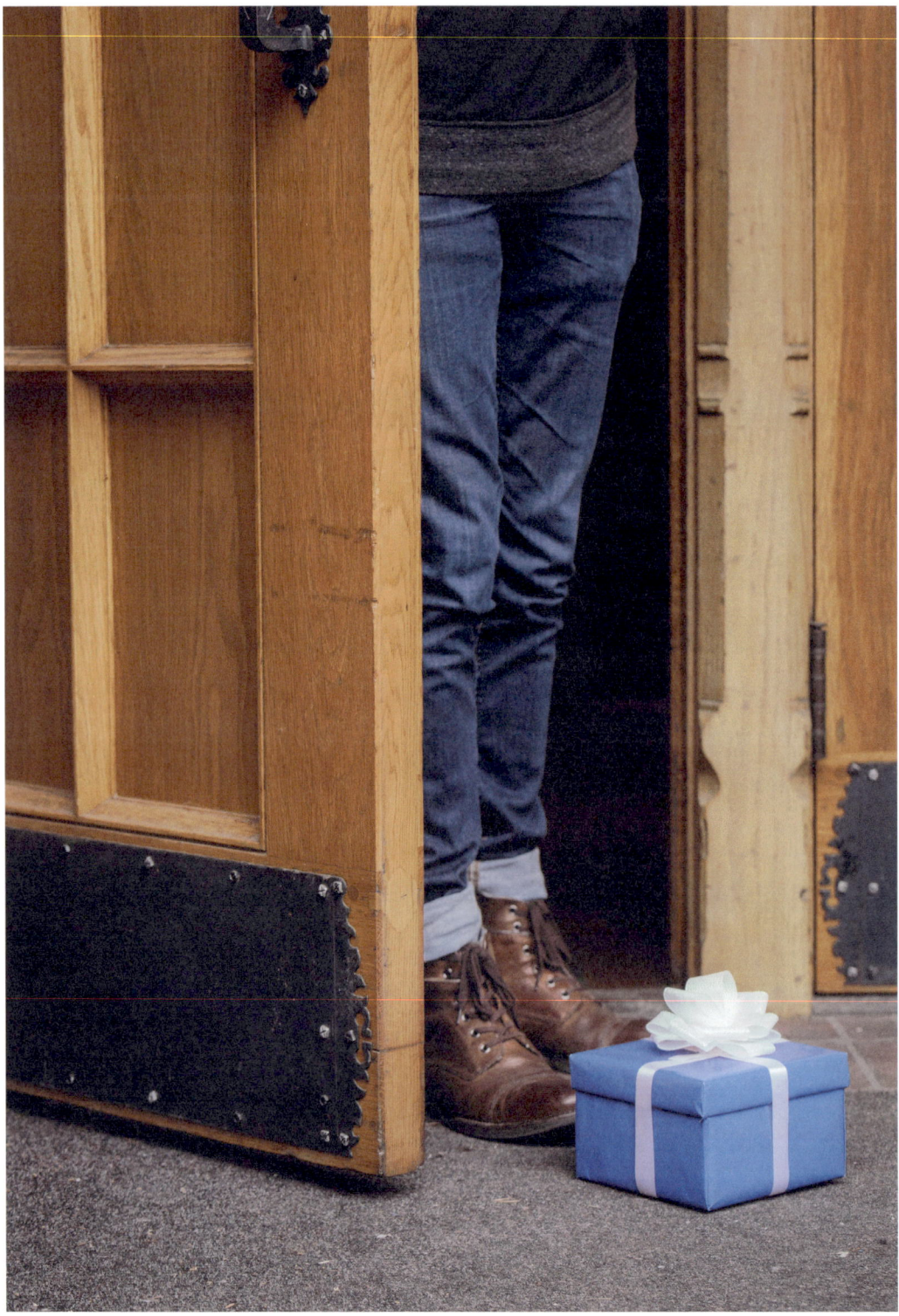

8

JESUS HEALS A MAN WITH LEPROSY

[1] Large crowds followed Jesus as he came down the mountainside. [2] Suddenly, a man with leprosy approached him and knelt before him. "Lord," the man said, "if you are willing, you can heal me and make me clean." [3] Jesus reached out and touched him. "I am willing," he said. "Be healed!" And instantly the leprosy disappeared. [4] Then Jesus said to him, "Don't tell anyone about this. Instead, go to the priest and let him examine you. Take along the offering required in the law of Moses for those who have been healed of leprosy. This will be a public testimony that you have been cleansed."

THE FAITH OF A ROMAN OFFICER

[5] When Jesus returned to Capernaum, a Roman officer came and pleaded with him, [6] "Lord, my young servant lies in bed, paralyzed and in terrible pain." [7] Jesus said, "I will come and heal him." [8] But the officer said, "Lord, I am not worthy to have you come into my home. Just say the word from where you are, and my servant will be healed. [9] I know this because I am under the authority of my superior officers, and I have authority over my soldiers. I only need to say, 'Go,' and they go, or 'Come,' and they come. And if I say to my slaves, 'Do this,' they do it." [10] When Jesus heard this, he was amazed. Turning to those who were following him, he said, "I tell you the truth, I haven't seen faith like this in all Israel! [11] And I tell you this, that many Gentiles will come from all over the world—from east and west—and sit down with Abraham, Isaac, and Jacob at the feast in the Kingdom of Heaven. [12] But many Israelites—those for whom the Kingdom was prepared—will be thrown into outer darkness, where there will be weeping and gnashing of teeth." [13] Then Jesus said to the Roman officer, "Go back home. Because you believed, it has happened." And the young servant was healed that same hour.

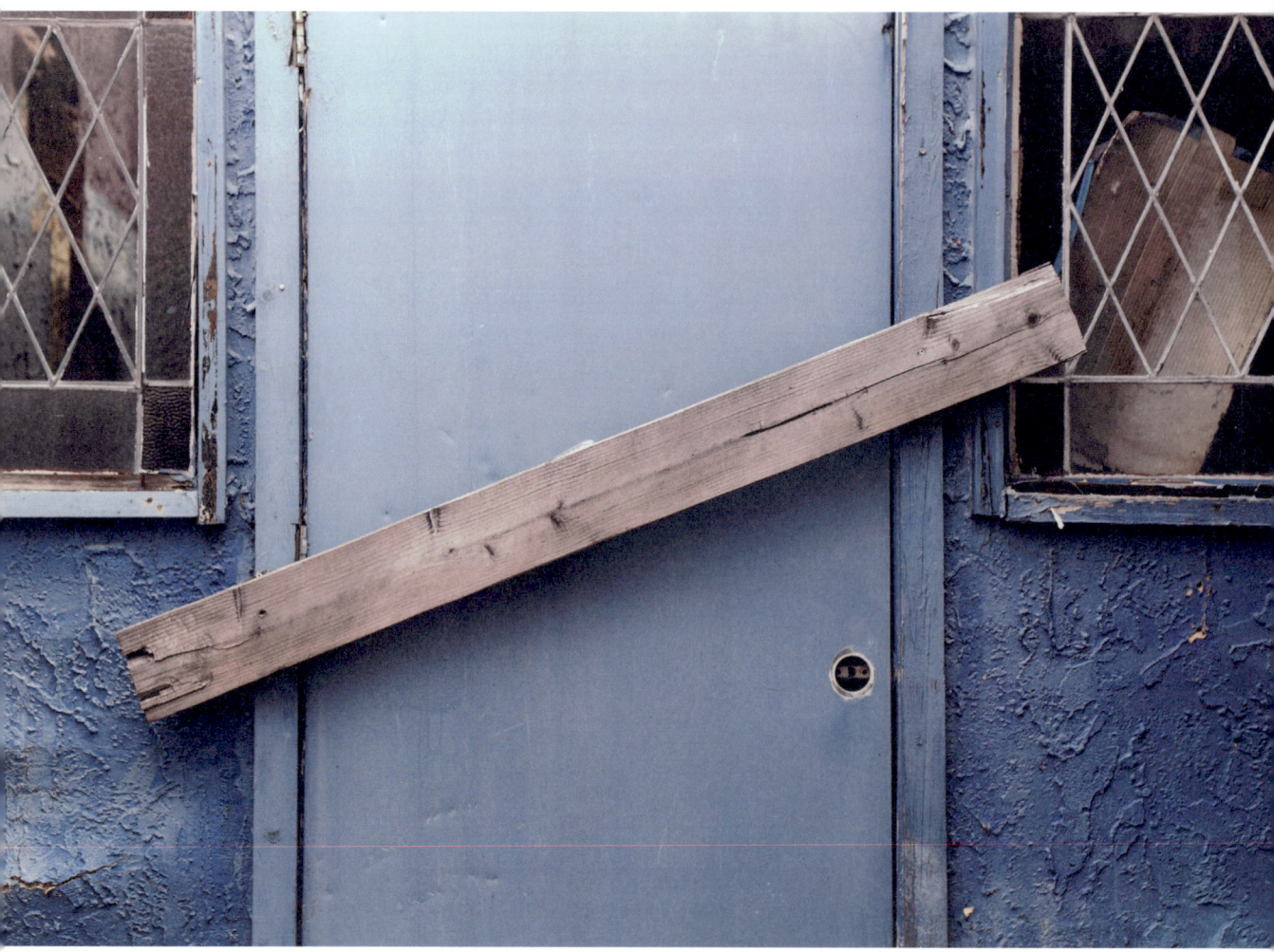

JESUS HEALS MANY PEOPLE

[14] When Jesus arrived at Peter's house, Peter's mother-in-law was sick in bed with a high fever. [15] But when Jesus touched her hand, the fever left her. Then she got up and prepared a meal for him. [16] That evening many demon-possessed people were brought to Jesus. He cast out the evil spirits with a simple command, and he healed all the sick. [17] This fulfilled the word of the Lord through the prophet Isaiah, who said, "He took our sicknesses and removed our diseases."

THE COST OF FOLLOWING JESUS

[18] When Jesus saw the crowd around him, he instructed his disciples to cross to the other side of the lake. [19] Then one of the teachers of religious law said to him, "Teacher, I will follow you wherever you go." [20] But Jesus replied, "Foxes have dens to live in, and birds have nests, but the Son of Man has no place even to lay his head." [21] Another of his disciples said, "Lord, first let me return home and bury my father." [22] But Jesus told him, "Follow me now. Let the spiritually dead bury their own dead."

JESUS CALMS THE STORM

[23] Then Jesus got into the boat and started across the lake with his disciples. [24] Suddenly, a fierce storm struck the lake, with waves breaking into the boat. But Jesus was sleeping. [25] The disciples went and woke him up, shouting, "Lord, save us! We're going to drown!" [26] Jesus responded, "Why are you afraid? You have so little faith!" Then he got up and rebuked the wind and waves, and suddenly there was a great calm. [27] The disciples were amazed. "Who is this man?" they asked. "Even the winds and waves obey him!"

JESUS HEALS TWO DEMON-POSSESSED MEN

[28] When Jesus arrived on the other side of the lake, in the region of the Gadarenes, two men who were possessed by demons met him. They came out of the tombs and were so violent that no one could go through that area. [29] They began screaming at him, "Why are you interfering with us, Son of God? Have you come here to torture us before God's appointed time?" [30] There happened to be a large herd of pigs feeding in the distance. [31] So the demons begged, "If you cast us out, send us into that herd of pigs." [32] "All right, go!" Jesus commanded them. So the demons came out of the men and entered the pigs, and the whole herd plunged down the steep hillside into the lake and drowned in the water. [33] The herdsmen fled to the nearby town, telling everyone what happened to the demon-possessed men. [34] Then the entire town came out to meet Jesus, but they begged him to go away and leave them alone.

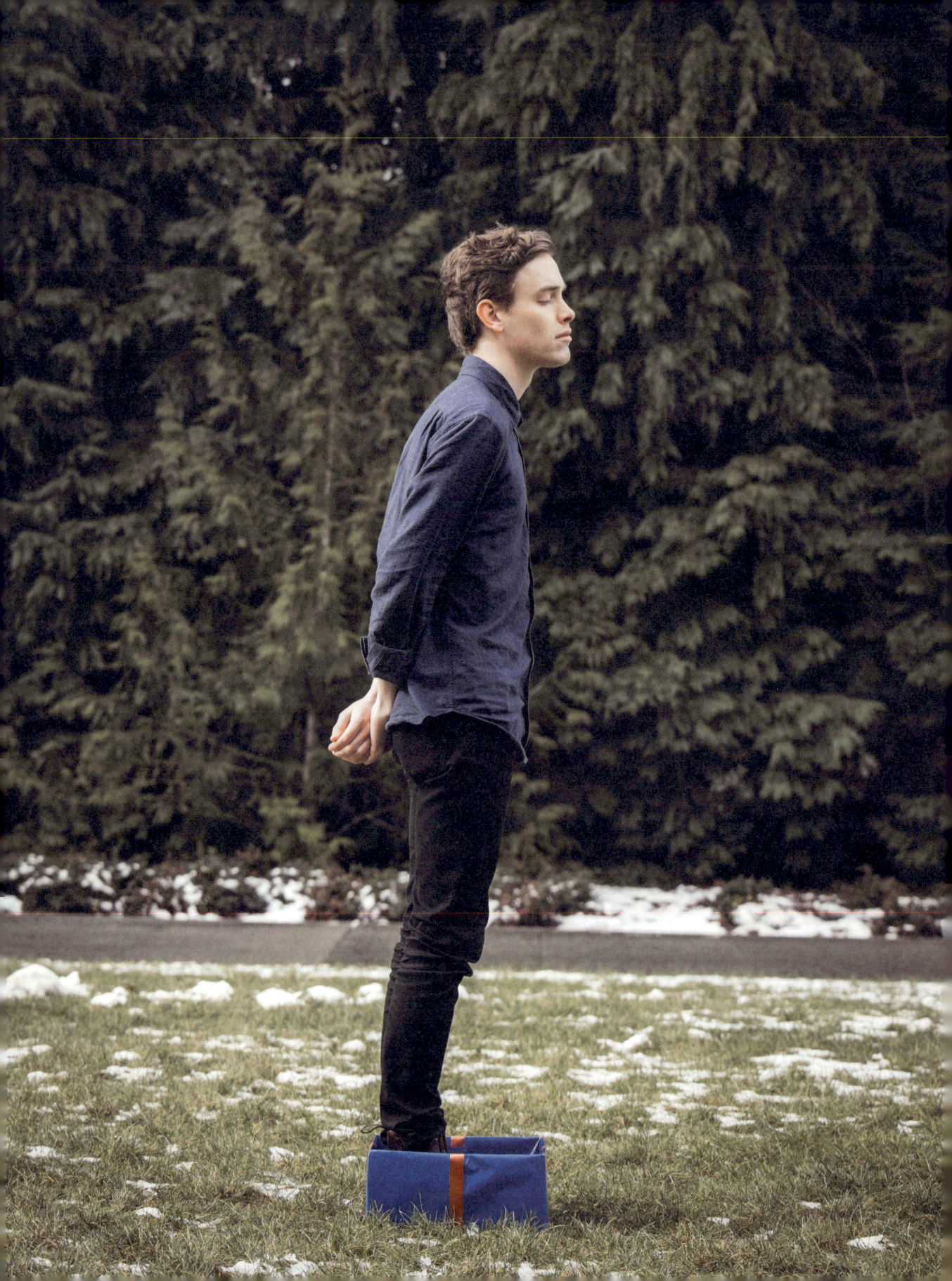

9

JESUS HEALS A PARALYZED MAN

[1] Jesus climbed into a boat and went back across the lake to his own town. [2] Some people brought to him a paralyzed man on a mat. Seeing their faith, Jesus said to the paralyzed man, "Be encouraged, my child! Your sins are forgiven." [3] But some of the teachers of religious law said to themselves, "That's blasphemy! Does he think he's God?" [4] Jesus knew what they were thinking, so he asked them, "Why do you have such evil thoughts in your hearts? [5] Is it easier to say 'Your sins are forgiven,' or 'Stand up and walk'? [6] So I will prove to you that the Son of Man has the authority on earth to forgive sins." Then Jesus turned to the paralyzed man and said, "Stand up, pick up your mat, and go home!" [7] And the man jumped up and went home! [8] Fear swept through the crowd as they saw this happen. And they praised God for giving humans such authority.

JESUS CALLS MATTHEW

[9] As Jesus was walking along, he saw a man named Matthew sitting at his tax collector's booth. "Follow me and be my disciple," Jesus said to him. So Matthew got up and followed him. [10] Later, Matthew invited Jesus and his disciples to his home as dinner guests, along with many tax collectors and other disreputable sinners. [11] But when the Pharisees saw this, they asked his disciples, "Why does your teacher eat with such scum?" [12] When Jesus heard this, he said, "Healthy people don't need a doctor—sick people do." [13] Then he added, "Now go and learn the meaning of this Scripture: 'I want you to show mercy, not offer sacrifices.' For I have come to call not those who think they are righteous, but those who know they are sinners."

A DISCUSSION ABOUT FASTING

[14] One day the disciples of John the Baptist came to Jesus and asked him, "Why don't your disciples fast like we do and the Pharisees do?" [15] Jesus replied, "Do wedding guests mourn while celebrating with the groom? Of course not. But someday the groom will be taken away from them, and then they will fast. [16] "Besides, who would patch old clothing with new cloth? For the new patch would shrink and rip away from the old cloth, leaving an even bigger tear than before. [17] "And no one puts new wine into old wineskins. For the old skins would burst from the pressure, spilling the wine and ruining the skins. New wine is stored in new wineskins so that both are preserved."

JESUS HEALS IN RESPONSE TO FAITH

[18] As Jesus was saying this, the leader of a synagogue came and knelt before him. "My daughter has just died," he said, "but you can bring her back to life again if you just come and lay your hand on her." [19] So Jesus and his disciples got up and went with him. [20] Just then a woman who had suffered for twelve years with constant bleeding came up behind him. She touched the fringe of his robe, [21] for she thought, "If I can just touch his robe, I will be healed." [22] Jesus turned around, and when he saw her he said, "Daughter, be encouraged! Your faith has made you well." And the woman was healed at that moment. [23] When Jesus arrived at the official's home, he saw the noisy crowd and heard the funeral music. [24] "Get out!" he told them. "The girl isn't dead; she's only asleep." But the crowd laughed at him. [25] After the crowd was put outside, however, Jesus went in and took the girl by the hand, and she stood up! [26] The report of this miracle swept through the entire countryside.

JESUS HEALS THE BLIND

[27] After Jesus left the girl's home, two blind men followed along behind him, shouting, "Son of David, have mercy on us!" [28] They went right into the house where he was staying, and Jesus asked them, "Do you believe I can make you see?" "Yes, Lord," they told him, "we do." [29] Then he touched their eyes and said, "Because of your faith, it will happen." [30] Then their eyes were opened, and they could see! Jesus sternly warned them, "Don't tell anyone about this." [31] But instead, they went out and spread his fame all over the region. [32] When they left, a demon-possessed man who couldn't speak was brought to Jesus. [33] So Jesus cast out the demon, and then the man began to speak. The crowds were amazed. "Nothing like this has ever happened in Israel!" they exclaimed. [34] But the Pharisees said, "He can cast out demons because he is empowered by the prince of demons."

THE NEED FOR WORKERS

[35] Jesus traveled through all the towns and villages of that area, teaching in the synagogues and announcing the Good News about the Kingdom. And he healed every kind of disease and illness. [36] When he saw the crowds, he had compassion on them because they were confused and helpless, like sheep without a shepherd. [37] He said to his disciples, "The harvest is great, but the workers are few. [38] So pray to the Lord who is in charge of the harvest; ask him to send more workers into his fields."

CHAPTER 9

10

JESUS SENDS OUT THE TWELVE APOSTLES

[1] Jesus called his twelve disciples together and gave them authority to cast out evil spirits and to heal every kind of disease and illness. [2] Here are the names of the twelve apostles: first, Simon (also called Peter), then Andrew (Peter's brother), James (son of Zebedee), John (James's brother), [3] Philip, Bartholomew, Thomas, Matthew (the tax collector), James (son of Alphaeus), Thaddaeus, [4] Simon (the zealot), Judas Iscariot (who later betrayed him). [5] Jesus sent out the twelve apostles with these instructions: "Don't go to the Gentiles or the Samaritans, [6] but only to the people of Israel—God's lost sheep. [7] Go and announce to them that the Kingdom of Heaven is near. [8] Heal the sick, raise the dead, cure those with leprosy,

and cast out demons. Give as freely as you have received! ⁹ "Don't take any money in your money belts—no gold, silver, or even copper coins. ¹⁰ Don't carry a traveler's bag with a change of clothes and sandals or even a walking stick. Don't hesitate to accept hospitality, because those who work deserve to be fed. ¹¹ "Whenever you enter a city or village, search for a worthy person and stay in his home until you leave town. ¹² When you enter the home, give it your blessing. ¹³ If it turns out to be a worthy home, let your blessing stand; if it is not, take back the blessing. ¹⁴ If any household or town refuses to welcome you or listen to your message, shake its dust from your feet as you leave. ¹⁵ I tell you the truth, the wicked cities of Sodom and Gomorrah will be better off than such a town on the judgment day. ¹⁶ "Look, I am sending you out as sheep among wolves. So be as shrewd as snakes and harmless as doves. ¹⁷ But beware! For you will be handed over to the courts and will be flogged with whips in the synagogues. ¹⁸ You will stand trial before governors and kings because you are my followers. But this will be your opportunity to tell the rulers and other unbelievers about me. ¹⁹ When you are arrested, don't worry about how to respond or what to say. God will give you the right words at the right time. ²⁰ For it is not you who will be speaking—it will be the Spirit of your Father speaking through you. ²¹ "A brother will betray his brother to death, a father will betray his own child, and children will rebel against their parents and cause them to be killed. ²² And all nations will hate you because you are my followers. But everyone who endures to the end will be saved. ²³ When you are persecuted in one town, flee to the next. I tell you the truth, the Son of Man will return before you have reached all the towns of Israel. ²⁴ "Students are not greater than their teacher, and slaves are not greater than their master. ²⁵ Students are to be like their teacher, and slaves are to be like their master. And since I, the master of the household, have been called the prince of demons, the members of my household will be called by even worse names! ²⁶ "But don't be afraid of those who threaten you. For the time is coming when everything that is covered will be revealed, and all that is secret will be made known to all. ²⁷ What I tell you now in the darkness, shout abroad when daybreak comes. What I whisper in your ear, shout from the housetops for all to hear! ²⁸ "Don't be afraid of those who want to kill your body; they cannot touch your soul. Fear only God, who can destroy both soul and body in hell. ²⁹ What is the price of two sparrows—one copper coin? But not a single sparrow can fall to the ground without your Father knowing it. ³⁰ And the very hairs on your head are all numbered. ³¹ So don't be afraid; you are more valuable to God than a whole flock of sparrows. ³² "Everyone who acknowledges me publicly here on earth, I will also acknowledge before my Father in heaven. ³³ But everyone who denies me here on earth, I will also deny before my Father in heaven. ³⁴ "Don't imagine that I came to bring peace to the earth! I came not to bring peace, but a sword. ³⁵ 'I have come to set a man against his father, a daughter against her mother, and a daughter-in-law against her mother-in-law. ³⁶ Your enemies will be right in your own household!' ³⁷ "If you love your father or mother more than you love me, you are not worthy of being mine; or if you love your son or daughter more than me, you are not worthy of being mine. ³⁸ If you refuse to take up your cross and follow me, you are not worthy of being mine. ³⁹ If you cling to your life, you will lose it; but if you give up your life for me, you will find it. ⁴⁰ "Anyone who receives you receives me, and anyone who receives me receives the Father who sent me. ⁴¹ If you receive a prophet as one who speaks for God, you will be given the same reward as a prophet. And if you receive righteous people because of their righteousness, you will be given a reward like theirs. ⁴² And if you give even a cup of cold water to one of the least of my followers, you will surely be rewarded."

11

JESUS AND JOHN THE BAPTIST

¹ When Jesus had finished giving these instructions to his twelve disciples, he went out to teach and preach in towns throughout the region. ² John the Baptist, who was in prison, heard about all the things the Messiah was doing. So he sent his disciples to ask Jesus, ³ "Are you the Messiah we've been expecting, or should we keep looking for someone else?" ⁴ Jesus told them, "Go back to John and tell him what you have heard and seen— ⁵ the blind see, the lame walk, those with leprosy are cured, the deaf hear, the dead are raised to life, and the Good News is being preached to the poor." ⁶ And he added, "God blesses those who do not fall away because of me." ⁷ As John's disciples were leaving, Jesus began talking about him to the crowds. "What kind of man did you go into the wilderness to see? Was he a weak reed, swayed by every breath of wind? ⁸ Or were you expecting to see a man dressed in expensive clothes? No, people with expensive clothes live in palaces. ⁹ Were you looking for a prophet? Yes, and he is more than a prophet. ¹⁰ John is the man to whom the Scriptures refer when they say, 'Look, I am sending my messenger ahead of you, and he will prepare your way before you.' ¹¹ "I tell you the truth, of all who have ever lived, none is greater than John the Baptist. Yet even the least person in the Kingdom of Heaven is greater than he is! ¹² And from the time John the Baptist began preaching until now, the Kingdom of Heaven has been forcefully advancing, and violent people are attacking it. ¹³ For before John came, all the prophets and the law of Moses looked forward to this present time. ¹⁴ And if you are willing to accept what I say, he is Elijah, the one the prophets said would come. ¹⁵ Anyone with ears to hear should listen and understand! ¹⁶ "To what can I compare this generation? It is like children playing a game in the public square. They complain to their friends, ¹⁷ 'We played wedding songs, and you didn't dance, so we played funeral songs, and you didn't mourn.' ¹⁸ For John didn't spend his time eating and drinking, and you say, 'He's possessed by a demon.' ¹⁹ The Son of Man, on the other hand, feasts and drinks, and you say, 'He's a glutton and a drunkard, and a friend of tax collectors and other sinners!' But wisdom is shown to be right by its results."

ALABASTER | GOSPEL OF MATTHEW

JUDGMENT FOR THE UNBELIEVERS

[20] Then Jesus began to denounce the towns where he had done so many of his miracles, because they hadn't repented of their sins and turned to God. [21] "What sorrow awaits you, Korazin and Bethsaida! For if the miracles I did in you had been done in wicked Tyre and Sidon, their people would have repented of their sins long ago, clothing themselves in burlap and throwing ashes on their heads to show their remorse. [22] I tell you, Tyre and Sidon will be better off on judgment day than you. [23] "And you people of Capernaum, will you be honored in heaven? No, you will go down to the place of the dead. For if the miracles I did for you had been done in wicked Sodom, it would still be here today. [24] I tell you, even Sodom will be better off on judgment day than you."

JESUS' PRAYER OF THANKSGIVING

[25] At that time Jesus prayed this prayer: "O Father, Lord of heaven and earth, thank you for hiding these things from those who think themselves wise and clever, and for revealing them to the childlike. [26] Yes, Father, it pleased you to do it this way! [27] "My Father has entrusted everything to me. No one truly knows the Son except the Father, and no one truly knows the Father except the Son and those to whom the Son chooses to reveal him." [28] Then Jesus said, "Come to me, all of you who are weary and carry heavy burdens, and I will give you rest. [29] Take my yoke upon you. Let me teach you, because I am humble and gentle at heart, and you will find rest for your souls. [30] For my yoke is easy to bear, and the burden I give you is light."

ALABASTER | GOSPEL OF MATTHEW

12

A DISCUSSION ABOUT THE SABBATH

[1] At about that time Jesus was walking through some grainfields on the Sabbath. His disciples were hungry, so they began breaking off some heads of grain and eating them. [2] But some Pharisees saw them do it and protested, "Look, your disciples are breaking the law by harvesting grain on the Sabbath." [3] Jesus said to them, "Haven't you read in the Scriptures what David did when he and his companions were hungry? [4] He went into the house of God, and he and his companions broke the law by eating the sacred loaves of bread that only the priests are allowed to eat. [5] And haven't you read in the law of Moses that the priests on duty in the Temple may work on the Sabbath? [6] I tell you, there is one here who is even greater than the Temple! [7] But you would not have condemned my innocent disciples if you knew the meaning of this Scripture: 'I want you to show mercy, not offer sacrifices.' [8] For the Son of Man is Lord, even over the Sabbath!"

JESUS HEALS ON THE SABBATH

[9] Then Jesus went over to their synagogue, [10] where he noticed a man with a deformed hand. The Pharisees asked Jesus, "Does the law permit a person to work by healing on the Sabbath?" (They were hoping he would say yes, so they could bring charges against him.) [11] And he answered, "If you had a sheep that fell into a well on the Sabbath, wouldn't you work to pull it out? Of course you would. [12] And how much more valuable is a person than a sheep! Yes, the law permits a person to do good on the Sabbath." [13] Then he said to the man, "Hold out your hand." So the man held out his hand, and it was restored, just like the other one! [14] Then the Pharisees called a meeting to plot how to kill Jesus.

JESUS, GOD'S CHOSEN SERVANT

[15] But Jesus knew what they were planning. So he left that area, and many people followed him. He healed all the sick among them, [16] but he warned them not to reveal who he was. [17] This fulfilled the prophecy of Isaiah concerning him: [18] "Look at my Servant, whom I have chosen. He is my Beloved, who pleases me. I will put my Spirit upon him, and he will proclaim justice to the nations. [19] He will not fight or shout or raise his voice in public. [20] He will not crush the weakest reed or put out a flickering candle. Finally he will cause justice to be victorious. [21] And his name will be the hope of all the world."

JESUS AND THE PRINCE OF DEMONS

22 Then a demon-possessed man, who was blind and couldn't speak, was brought to Jesus. He healed the man so that he could both speak and see. 23 The crowd was amazed and asked, "Could it be that Jesus is the Son of David, the Messiah?" 24 But when the Pharisees heard about the miracle, they said, "No wonder he can cast out demons. He gets his power from Satan, the prince of demons." 25 Jesus knew their thoughts and replied, "Any kingdom divided by civil war is doomed. A town or family splintered by feuding will fall apart. 26 And if Satan is casting out Satan, he is divided and fighting against himself. His own kingdom will not survive. 27 And if I am empowered by Satan, what about your own exorcists? They cast out demons, too, so they will condemn you for what you have said. 28 But if I am casting out demons by the Spirit of God, then the Kingdom of God has arrived among you. 29 For who is powerful enough to enter the house of a strong man and plunder his goods? Only someone even stronger—someone who could tie him up and then plunder his house. 30 "Anyone who isn't with me opposes me, and anyone who isn't working with me is actually working against me. 31 "So I tell you, every sin and blasphemy can be forgiven—except blasphemy against the Holy Spirit, which will never be forgiven. 32 Anyone who speaks against the Son of Man can be forgiven, but anyone who speaks against the Holy Spirit will never be forgiven, either in this world or in the world to come. 33 "A tree is identified by its fruit. If a tree is good, its fruit will be good. If a tree is bad, its fruit will be bad. 34 You brood of snakes! How could evil men like you speak what is good and right? For whatever is in your heart determines what you say. 35 A good person produces good things from the treasury of a good heart, and an evil person produces evil things from the treasury of an evil heart. 36 And I tell you this, you must give an account on judgment day for every idle word you speak. 37 The words you say will either acquit you or condemn you."

THE SIGN OF JONAH

38 One day some teachers of religious law and Pharisees came to Jesus and said, "Teacher, we want you to show us a miraculous sign to prove your authority." 39 But Jesus replied, "Only an evil, adulterous generation would demand a miraculous sign; but the only sign I will give them is the sign of the prophet Jonah. 40 For as Jonah was in the belly of the great fish for three days and three nights, so will the Son of Man be in the heart of the earth for three days and three nights. 41 "The people of Nineveh will stand up against this generation on judgment day and condemn it, for they repented of their sins at the preaching of Jonah. Now someone greater than Jonah is here—but you refuse to repent. 42 The queen of Sheba will also stand up against this generation on judgment day and condemn it, for she came from a distant land to hear the wisdom of Solomon. Now someone greater than Solomon is here—but you refuse to listen. 43 "When an evil spirit leaves a person, it goes into the desert, seeking rest but finding none. 44 Then it says, 'I will return to the person I came from.' So it returns and finds its former home empty, swept, and in order. 45 Then the spirit finds seven other spirits more evil than itself, and they all enter the person and live there. And so that person is worse off than before. That will be the experience of this evil generation."

THE TRUE FAMILY OF JESUS

46 As Jesus was speaking to the crowd, his mother and brothers stood outside, asking to speak to him. 47 Someone told Jesus, "Your mother and your brothers are standing outside, and they want to speak to you." 48 Jesus asked, "Who is my mother? Who are my brothers?" 49 Then he pointed to his disciples and said, "Look, these are my mother and brothers. 50 Anyone who does the will of my Father in heaven is my brother and sister and mother!"

13

PARABLE OF THE FARMER SCATTERING SEED

[1] Later that same day Jesus left the house and sat beside the lake. [2] A large crowd soon gathered around him, so he got into a boat. Then he sat there and taught as the people stood on the shore. [3] He told many stories in the form of parables, such as this one: "Listen! A farmer went out to plant some seeds. [4] As he scattered them across his field, some seeds fell on a footpath, and the birds came and ate them. [5] Other seeds fell on shallow soil with underlying rock. The seeds sprouted quickly because the soil was shallow. [6] But the plants soon wilted under the hot sun, and since they didn't have deep roots, they died. [7] Other seeds fell among thorns that grew up and choked out the tender plants. [8] Still other seeds fell on fertile soil, and they produced a crop that was thirty, sixty, and even a hundred times as much as had been planted! [9] Anyone with ears to hear should listen and understand." [10] His disciples came and asked him, "Why do you use parables when you talk to the people?" [11] He replied, "You are permitted to understand the secrets of the Kingdom of Heaven, but others are not. [12] To those who listen to my teaching, more understanding will be given, and they will have an abundance of knowledge. But for those who are not listening, even what little understanding they have will be taken away from them. [13] That is why I use these parables, For they look, but they don't really see. They hear, but they don't really listen or understand. [14] This fulfills the prophecy of Isaiah that says, 'When you hear what I say, you will not understand. When you see what I do, you will not comprehend. [15] For the hearts of these people are hardened, and their ears cannot hear, and they have closed their eyes— so their eyes cannot see, and their ears cannot hear, and their hearts cannot understand, and they cannot turn to me and let me heal them.' [16] "But blessed are your eyes, because they see; and your ears, because they hear. [17] I tell you the truth, many prophets and righteous people longed to see what you see, but they didn't see it. And they longed to hear what you hear, but they didn't hear it. [18] "Now listen to the explanation of the parable about the farmer planting seeds: [19] The seed that fell on the footpath represents those who hear the message about the Kingdom and don't understand it. Then the evil one comes and snatches away the seed that was planted in their hearts. [20] The seed on the rocky soil represents those who hear the message and immediately receive it with joy. [21] But since they don't have deep roots, they don't last long. They fall away as soon as they have problems or are persecuted for believing God's word. [22] The seed that fell among the thorns represents those who hear God's word, but all too quickly the message is crowded out by the worries of this life and the lure of wealth, so no fruit is produced. [23] The seed that fell on good soil represents those who truly hear and understand God's word and produce a harvest of thirty, sixty, or even a hundred times as much as had been planted!"

PARABLE OF THE WHEAT AND WEEDS

[24] Here is another story Jesus told: "The Kingdom of Heaven is like a farmer who planted good seed in his field. [25] But that night as the workers slept, his enemy came and planted weeds among the wheat, then slipped away. [26] When the crop began to grow and produce grain, the weeds also grew. [27] "The farmer's workers went to him and said, 'Sir, the field where you planted that good seed is full of weeds! Where did they come from?' [28] "'An enemy has done this!' the farmer exclaimed. "'Should we pull out the weeds?' they asked. [29] "'No,' he replied, 'you'll uproot the wheat if you do. [30] Let both grow together until the harvest. Then I will tell the harvesters to sort out the weeds, tie them into bundles, and burn them, and to put the wheat in the barn.'"

ALABASTER | GOSPEL OF MATTHEW

PARABLE OF THE MUSTARD SEED

[31] Here is another illustration Jesus used: "The Kingdom of Heaven is like a mustard seed planted in a field. [32] It is the smallest of all seeds, but it becomes the largest of garden plants; it grows into a tree, and birds come and make nests in its branches."

PARABLE OF THE YEAST

[33] Jesus also used this illustration: "The Kingdom of Heaven is like the yeast a woman used in making bread. Even though she put only a little yeast in three measures of flour, it permeated every part of the dough." [34] Jesus always used stories and illustrations like these when speaking to the crowds. In fact, he never spoke to them without using such parables. [35] This fulfilled what God had spoken through the prophet: "I will speak to you in parables. I will explain things hidden since the creation of the world."

PARABLE OF THE WHEAT AND WEEDS EXPLAINED

[36] Then, leaving the crowds outside, Jesus went into the house. His disciples said, "Please explain to us the story of the weeds in the field." [37] Jesus replied, "The Son of Man is the farmer who plants the good seed. [38] The field is the world, and the good seed represents the people of the Kingdom. The weeds are the people who belong to the evil one. [39] The enemy who planted the weeds among the wheat is the devil. The harvest is the end of the world, and the harvesters are the angels. [40] "Just as the weeds are sorted out and burned in the fire, so it will be at the end of the world. [41] The Son of Man will send his angels, and they will remove from his Kingdom everything that causes sin and all who do evil. [42] And the angels will throw them into the fiery furnace, where there will be weeping and gnashing of teeth. [43] Then the righteous will shine like the sun in their Father's Kingdom. Anyone with ears to hear should listen and understand!

PARABLES OF THE HIDDEN TREASURE AND THE PEARL

[44] "The Kingdom of Heaven is like a treasure that a man discovered hidden in a field. In his excitement, he hid it again and sold everything he owned to get enough money to buy the field. [45] "Again, the Kingdom of Heaven is like a merchant on the lookout for choice pearls. [46] When he discovered a pearl of great value, he sold everything he owned and bought it!

PARABLE OF THE FISHING NET

[47] "Again, the Kingdom of Heaven is like a fishing net that was thrown into the water and caught fish of every kind. [48] When the net was full, they dragged it up onto the shore, sat down, and sorted the good fish into crates, but threw the bad ones away. [49] That is the way it will be at the end of the world. The angels will come and separate the wicked people from the righteous, [50] throwing the wicked into the fiery furnace, where there will be weeping and gnashing of teeth. [51] Do you understand all these things?" "Yes," they said, "we do." [52] Then he added, "Every teacher of religious law who becomes a disciple in the Kingdom of Heaven is like a homeowner who brings from his storeroom new gems of truth as well as old."

JESUS REJECTED AT NAZARETH

[53] When Jesus had finished telling these stories and illustrations, he left that part of the country. [54] He returned to Nazareth, his hometown. When he taught there in the synagogue, everyone was amazed and said, "Where does he get this wisdom and the power to do miracles?" [55] Then they scoffed, "He's just the carpenter's son, and we know Mary, his mother, and his brothers—James, Joseph, Simon, and Judas. [56] All his sisters live right here among us. Where did he learn all these things?" [57] And they were deeply offended and refused to believe in him. Then Jesus told them, "A prophet is honored everywhere except in his own hometown and among his own family." [58] And so he did only a few miracles there because of their unbelief.

CHAPTER 13

14

THE DEATH OF JOHN THE BAPTIST

[1] When Herod Antipas, the ruler of Galilee, heard about Jesus, [2] he said to his advisers, "This must be John the Baptist raised from the dead! That is why he can do such miracles." [3] For Herod had arrested and imprisoned John as a favor to his wife Herodias (the former wife of Herod's brother Philip). [4] John had been telling Herod, "It is against God's law for you to marry her." [5] Herod wanted to kill John, but he was afraid of a riot, because all the people believed John was a prophet. [6] But at a birthday party for Herod, Herodias's daughter performed a dance that greatly pleased him, [7] so he promised with a vow to give her anything she wanted. [8] At her mother's urging, the girl said, "I want the head of John the Baptist on a tray!" [9] Then the king regretted what he had said; but because of the vow he had made in front of his guests, he issued the necessary orders. [10] So John was beheaded in the prison, [11] and his head was brought on a tray and given to the girl, who took it to her mother. [12] Later, John's disciples came for his body and buried it. Then they went and told Jesus what had happened.

JESUS FEEDS FIVE THOUSAND

[13] As soon as Jesus heard the news, he left in a boat to a remote area to be alone. But the crowds heard where he was headed and followed on foot from many towns. [14] Jesus saw the huge crowd as he stepped from the boat, and he had compassion on them and healed their sick. [15] That evening the disciples came to him and said, "This is a remote place, and it's already getting late. Send the crowds away so they can go to the villages and buy food for themselves." [16] But Jesus said, "That isn't necessary—you feed them." [17] "But we have only five loaves of bread and two fish!" they answered. [18] "Bring them here," he said. [19] Then he told the people to sit down on the grass. Jesus took the five loaves and two fish, looked up toward heaven, and blessed them. Then, breaking the loaves into pieces, he gave the bread to the disciples, who distributed it to the people. [20] They all ate as much as they wanted, and afterward, the disciples picked up twelve baskets of leftovers. [21] About 5,000 men were fed that day, in addition to all the women and children!

JESUS WALKS ON WATER

²² Immediately after this, Jesus insisted that his disciples get back into the boat and cross to the other side of the lake, while he sent the people home. ²³ After sending them home, he went up into the hills by himself to pray. Night fell while he was there alone. ²⁴ Meanwhile, the disciples were in trouble far away from land, for a strong wind had risen, and they were fighting heavy waves. ²⁵ About three o'clock in the morning Jesus came toward them, walking on the water. ²⁶ When the disciples saw him walking on the water, they were terrified. In their fear, they cried out, "It's a ghost!" ²⁷ But Jesus spoke to them at once. "Don't be afraid," he said. "Take courage. I am here!" ²⁸ Then Peter called to him, "Lord, if it's really you, tell me to come to you, walking on the water." ²⁹ "Yes, come," Jesus said.

So Peter went over the side of the boat and walked on the water toward Jesus. [30] But when he saw the strong wind and the waves, he was terrified and began to sink. "Save me, Lord!" he shouted. [31] Jesus immediately reached out and grabbed him. "You have so little faith," Jesus said. "Why did you doubt me?" [32] When they climbed back into the boat, the wind stopped. [33] Then the disciples worshiped him. "You really are the Son of God!" they exclaimed.

[34] After they had crossed the lake, they landed at Gennesaret. [35] When the people recognized Jesus, the news of his arrival spread quickly throughout the whole area, and soon people were bringing all their sick to be healed. [36] They begged him to let the sick touch at least the fringe of his robe, and all who touched him were healed.

ALABASTER | GOSPEL OF MATTHEW

15

JESUS TEACHES ABOUT INNER PURITY

[1] Some Pharisees and teachers of religious law now arrived from Jerusalem to see Jesus. They asked him, [2] "Why do your disciples disobey our age-old tradition? For they ignore our tradition of ceremonial hand washing before they eat." [3] Jesus replied, "And why do you, by your traditions, violate the direct commandments of God? [4] For instance, God says, 'Honor your father and mother,' and 'Anyone who speaks disrespectfully of father or mother must be put to death.' [5] But you say it is all right for people to say to their parents, 'Sorry, I can't help you. For I have vowed to give to God what I would have given to you.' [6] In this way, you say they don't need to honor their parents. And so you cancel the word of God for the sake of your own tradition. [7] You hypocrites! Isaiah was right when he prophesied about you, for he wrote, [8] 'These people honor me with their lips, but their hearts are far from me. [9] Their worship is a farce, for they teach man-made ideas as commands from God.'" [10] Then Jesus called to the crowd to come and hear. "Listen," he said, "and try to understand. [11] It's not what goes into your mouth that defiles you; you are defiled by the words that come out of your mouth." [12] Then the disciples came to him and asked, "Do you realize you offended the Pharisees by what you just said?" [13] Jesus replied, "Every plant not planted by my heavenly Father will be uprooted, [14] so ignore them. They are blind guides leading the blind, and if one blind person guides another, they will both fall into a ditch." [15] Then Peter said to Jesus, "Explain to us the parable that says people aren't defiled by what they eat." [16] "Don't you understand yet?" Jesus asked. [17] "Anything you eat passes through the stomach and then goes into the sewer. [18] But the words you speak come from the heart—that's what defiles you. [19] For from the heart come evil thoughts, murder, adultery, all sexual immorality, theft, lying, and slander. [20] These are what defile you. Eating with unwashed hands will never defile you."

THE FAITH OF A GENTILE WOMAN

[21] Then Jesus left Galilee and went north to the region of Tyre and Sidon. [22] A Gentile woman who lived there came to him, pleading, "Have mercy on me, O Lord, Son of David! For my daughter is possessed by a demon that torments her severely." [23] But Jesus gave her no reply, not even a word. Then his disciples urged him to send her away. "Tell her to go away," they said. "She is bothering us with all her begging." [24] Then Jesus said to the woman, "I was sent only to help God's lost sheep—the people of Israel." [25] But she came and worshiped him, pleading again, "Lord, help me!" [26] Jesus responded, "It isn't right to take food from the children and throw it to the dogs." [27] She replied, "That's true, Lord, but even dogs are allowed to eat the scraps that fall beneath their masters' table." [28] "Dear woman," Jesus said to her, "your faith is great. Your request is granted." And her daughter was instantly healed.

JESUS HEALS MANY PEOPLE

²⁹ Jesus returned to the Sea of Galilee and climbed a hill and sat down. ³⁰ A vast crowd brought to him people who were lame, blind, crippled, those who couldn't speak, and many others. They laid them before Jesus, and he healed them all. ³¹ The crowd was amazed! Those who hadn't been able to speak were talking, the crippled were made well, the lame were walking, and the blind could see again! And they praised the God of Israel.

JESUS FEEDS FOUR THOUSAND

³² Then Jesus called his disciples and told them, "I feel sorry for these people. They have been here with me for three days, and they have nothing left to eat. I don't want to send them away hungry, or

CHAPTER 15

they will faint along the way." ³³ The disciples replied, "Where would we get enough food here in the wilderness for such a huge crowd?" ³⁴ Jesus asked, "How much bread do you have?" They replied, "Seven loaves, and a few small fish." ³⁵ So Jesus told all the people to sit down on the ground. ³⁶ Then he took the seven loaves and the fish, thanked God for them, and broke them into pieces. He gave them to the disciples, who distributed the food to the crowd. ³⁷ They all ate as much as they wanted. Afterward, the disciples picked up seven large baskets of leftover food. ³⁸ There were 4,000 men who were fed that day, in addition to all the women and children. ³⁹ Then Jesus sent the people home, and he got into a boat and crossed over to the region of Magadan.

16

LEADERS DEMAND A MIRACULOUS SIGN

[1] One day the Pharisees and Sadducees came to test Jesus, demanding that he show them a miraculous sign from heaven to prove his authority. [2] He replied, "You know the saying, 'Red sky at night means fair weather tomorrow; [3] red sky in the morning means foul weather all day.' You know how to interpret the weather signs in the sky, but you don't know how to interpret the signs of the times! [4] Only an evil, adulterous generation would demand a miraculous sign, but the only sign I will give them is the sign of the prophet Jonah." Then Jesus left them and went away.

YEAST OF THE PHARISEES AND SADDUCEES

[5] Later, after they crossed to the other side of the lake, the disciples discovered they had forgotten to bring any bread. [6] "Watch out!" Jesus warned them. "Beware of the yeast of the Pharisees and Sadducees." [7] At this they began to argue with each other because they hadn't brought any bread. [8] Jesus knew what they were saying, so he said, "You have so little faith! Why are you arguing with each other about having no bread? [9] Don't you understand even yet? Don't you remember the 5,000 I fed with five loaves, and the baskets of leftovers you picked up? [10] Or the 4,000 I fed with seven loaves, and the large baskets of leftovers you picked up? [11] Why can't you understand that I'm not talking about bread? So again I say, 'Beware of the yeast of the Pharisees and Sadducees.'" [12] Then at last they understood that he wasn't speaking about the yeast in bread, but about the deceptive teaching of the Pharisees and Sadducees.

PETER'S DECLARATION ABOUT JESUS

[13] When Jesus came to the region of Caesarea Philippi, he asked his disciples, "Who do people say that the Son of Man is?" [14] "Well," they replied, "some say John the Baptist, some say Elijah, and others say Jeremiah or one of the other prophets." [15] Then he asked them, "But who do you say I am?" [16] Simon Peter answered, "You are the Messiah, the Son of the living God." [17] Jesus replied, "You are blessed, Simon son of John, because my Father in heaven has revealed this to you. You did not learn this from any human being. [18] Now I say to you that you are Peter (which means 'rock'), and upon this rock I will build my church, and all the powers of hell will not conquer it. [19] And I will give you the keys of the Kingdom of Heaven. Whatever you forbid on earth will be forbidden in heaven, and whatever you permit on earth will be permitted in heaven." [20] Then he sternly warned the disciples not to tell anyone that he was the Messiah.

JESUS PREDICTS HIS DEATH

[21] From then on Jesus began to tell his disciples plainly

CHAPTER 16

that it was necessary for him to go to Jerusalem, and that he would suffer many terrible things at the hands of the elders, the leading priests, and the teachers of religious law. He would be killed, but on the third day he would be raised from the dead. ²² But Peter took him aside and began to reprimand him for saying such things. "Heaven forbid, Lord," he said. "This will never happen to you!" ²³ Jesus turned to Peter and said, "Get away from me, Satan! You are a dangerous trap to me. You are seeing things merely from a human point of view, not from God's." ²⁴ Then Jesus said to his disciples, "If any of you wants to be my follower, you must give up your own way, take up your cross, and follow me. ²⁵ If you try to hang on to your life, you will lose it. But if you give up your life for my sake, you will save it. ²⁶ And what do you benefit if you gain the whole world but lose your own soul? Is anything worth more than your soul? ²⁷ For the Son of Man will come with his angels in the glory of his Father and will judge all people according to their deeds. ²⁸ And I tell you the truth, some standing here right now will not die before they see the Son of Man coming in his Kingdom."

17

THE TRANSFIGURATION

[1] Six days later Jesus took Peter and the two brothers, James and John, and led them up a high mountain to be alone. [2] As the men watched, Jesus' appearance was transformed so that his face shone like the sun, and his clothes became as white as light. [3] Suddenly, Moses and Elijah appeared and began talking with Jesus. [4] Peter exclaimed, "Lord, it's wonderful for us to be here! If you want, I'll make three shelters as memorials—one for you, one for Moses, and one for Elijah." [5] But even as he spoke, a bright cloud overshadowed them, and a voice from the cloud said, "This is my dearly loved Son, who brings me great joy. Listen to him." [6] The disciples were terrified and fell face down on the ground. [7] Then Jesus came over and touched them. "Get up," he said. "Don't be afraid." [8] And when they looked up, Moses and Elijah were gone, and they saw only Jesus. [9] As they went back down the mountain, Jesus commanded them, "Don't tell anyone what you have seen until the Son of Man has been raised from the dead." [10] Then his disciples asked him, "Why do the teachers of religious law insist that Elijah must return before the Messiah comes?" [11] Jesus replied, "Elijah is indeed coming first to get everything ready. [12] But I tell you, Elijah has already come, but he wasn't recognized, and they chose to abuse him. And in the same way they will also make the Son of Man suffer." [13] Then the disciples realized he was talking about John the Baptist.

JESUS HEALS A DEMON-POSSESSED BOY

[14] At the foot of the mountain, a large crowd was waiting for them. A man came and knelt before Jesus and said, [15] "Lord, have mercy on my son. He has seizures and suffers terribly. He often falls into the fire or into the water. [16] So I brought him to your disciples, but they couldn't heal him." [17] Jesus said, "You faithless and corrupt people! How long must I be with you? How long must I put up with you? Bring the boy here to me." [18] Then Jesus rebuked the demon in the boy, and it left him. From that moment the boy was well. [19] Afterward the disciples asked Jesus privately, "Why couldn't we cast out that demon?" [20] "You don't have enough faith," Jesus told them. "I tell you the truth, if you had faith even as small as a mustard seed, you could say to this mountain, 'Move from here to there,' and it would move. Nothing would be impossible."

JESUS AGAIN PREDICTS HIS DEATH

[22] After they gathered again in Galilee, Jesus told them, "The Son of Man is going to be betrayed into the hands of his enemies. [23] He will be killed, but on the third day he will be raised from the dead." And the disciples were filled with grief.

PAYMENT OF THE TEMPLE TAX

[24] On their arrival in Capernaum, the collectors of the Temple tax came to Peter and asked him, "Doesn't your teacher pay the Temple tax?" [25] "Yes, he does," Peter replied. Then he went into the house. But before he had a chance to speak, Jesus asked him, "What do you think, Peter? Do kings tax their own people or the people they have conquered?" [26] "They tax the people they have conquered," Peter replied. "Well, then," Jesus said, "the citizens are free! [27] However, we don't want to offend them, so go down to the lake and throw in a line. Open the mouth of the first fish you catch, and you will find a large silver coin. Take it and pay the tax for both of us."

18

THE GREATEST IN THE KINGDOM

¹ About that time the disciples came to Jesus and asked, "Who is greatest in the Kingdom of Heaven?" ² Jesus called a little child to him and put the child among them. ³ Then he said, "I tell you the truth, unless you turn from your sins and become like little children, you will never get into the Kingdom of Heaven. ⁴ So anyone who becomes as humble as this little child is the greatest in the Kingdom of Heaven. ⁵ "And anyone who welcomes a little child like this on my behalf is welcoming me. ⁶ But if you cause one of these little ones who trusts in me to fall into sin, it would be better for you to have a large millstone tied around your neck and be drowned in the depths of the sea. ⁷ "What sorrow awaits the world, because it tempts people to sin. Temptations are inevitable, but what sorrow awaits the person who does the tempting. ⁸ So if your hand or foot causes you to sin, cut it off and throw it away. It's better to enter eternal life with only one hand or one foot than to be thrown into eternal fire with both of your hands and feet. ⁹ And if your eye causes you to sin, gouge it out and throw it away. It's better to enter eternal life with only one eye than to have two eyes and be thrown into the fire of hell. ¹⁰ "Beware that you don't look down on any of these little ones. For I tell you that in heaven their angels are always in the presence of my heavenly Father.

ALABASTER | GOSPEL OF MATTHEW

PARABLE OF THE LOST SHEEP

[12] "If a man has a hundred sheep and one of them wanders away, what will he do? Won't he leave the ninety-nine others on the hills and go out to search for the one that is lost? [13] And if he finds it, I tell you the truth, he will rejoice over it more than over the ninety-nine that didn't wander away! [14] In the same way, it is not my heavenly Father's will that even one of these little ones should perish.

CORRECTING ANOTHER BELIEVER

[15] "If another believer sins against you, go privately and point out the offense. If the other person listens and confesses it, you have won that person back. [16] But if you are unsuccessful, take one or two others with you and go back again, so that everything you say may be confirmed by two or three witnesses. [17] If the person still refuses to listen, take your case to the church. Then if he or she won't accept the church's decision, treat that person as a pagan or a corrupt tax collector. [18] "I tell you the truth, whatever you forbid on earth will be forbidden in heaven, and whatever you permit on earth will be permitted in heaven. [19] "I also tell you this: If two of you agree here on earth concerning anything you ask, my Father in heaven will do it for you. [20] For where two or three gather together as my followers, I am there among them."

PARABLE OF THE UNFORGIVING DEBTOR

[21] Then Peter came to him and asked, "Lord, how often should I forgive someone who sins against me? Seven times?" [22] "No, not seven times," Jesus replied, "but seventy times seven! [23] "Therefore, the Kingdom of Heaven can be compared to a king who decided to bring his accounts up to date with servants who had borrowed money from him. [24] In the process, one of

CHAPTER 18

his debtors was brought in who owed him millions of dollars. ²⁵ He couldn't pay, so his master ordered that he be sold—along with his wife, his children, and everything he owned—to pay the debt. ²⁶ "But the man fell down before his master and begged him, 'Please, be patient with me, and I will pay it all.' ²⁷ Then his master was filled with pity for him, and he released him and forgave his debt. ²⁸ "But when the man left the king, he went to a fellow servant who owed him a few thousand dollars. He grabbed him by the throat and demanded instant payment. ²⁹ "His fellow servant fell down before him and begged for a little more time. 'Be patient with me, and I will pay it,' he pleaded. ³⁰ But his creditor wouldn't wait. He had the man arrested and put in prison until the debt could be paid in full. ³¹ "When some of the other servants saw this, they were very upset. They went to the king and told him everything that had happened. ³² Then the king called in the man he had forgiven and said, 'You evil servant! I forgave you that tremendous debt because you pleaded with me. ³³ Shouldn't you have mercy on your fellow servant, just as I had mercy on you?' ³⁴ Then the angry king sent the man to prison to be tortured until he had paid his entire debt. ³⁵ "That's what my heavenly Father will do to you if you refuse to forgive your brothers and sisters from your heart."

19

DISCUSSION ABOUT DIVORCE AND MARRIAGE

[1] When Jesus had finished saying these things, he left Galilee and went down to the region of Judea east of the Jordan River. [2] Large crowds followed him there, and he healed their sick. [3] Some Pharisees came and tried to trap him with this question: "Should a man be allowed to divorce his wife for just any reason?" [4] "Haven't you read the Scriptures?" Jesus replied. "They record that from the beginning 'God made them male and female.'" [5] And he said, "'This explains why a man leaves his father and mother and is joined to his wife, and the two are united into one.' [6] Since they are no longer two but one, let no one split apart what God has joined together." [7] "Then why did Moses say in the law that a man could give his wife a written notice of divorce and send her away?" they asked. [8] Jesus replied, "Moses permitted divorce only as a concession to your hard hearts, but it was not what God had originally intended. [9] And I tell you this, whoever divorces his wife and marries someone else commits adultery—unless his wife has been unfaithful." [10] Jesus' disciples then said to him, "If this is the case, it is better not to marry!" [11] "Not everyone can accept this statement," Jesus said. "Only those whom God helps. [12] Some are born as eunuchs, some have been made eunuchs by others, and some choose not to marry for the sake of the Kingdom of Heaven. Let anyone accept this who can."

JESUS BLESSES THE CHILDREN

[13] One day some parents brought their children to Jesus so he could lay his hands on them and pray for them. But the disciples scolded the parents for bothering him. [14] But Jesus said, "Let the children come to me. Don't stop them! For the Kingdom of Heaven belongs to those who are like these children." [15] And he placed his hands on their heads and blessed them before he left.

THE RICH MAN

[16] Someone came to Jesus with this question: "Teacher, what good deed must I do to have eternal life?" [17] "Why ask me about what is good?" Jesus replied. "There is only One who is good. But to answer your question—if you want to receive eternal life, keep the commandments." [18] "Which ones?" the man asked. And Jesus replied: "'You must not murder. You must not commit adultery. You must not steal. You must not testify falsely. [19] Honor your father and mother. Love your neighbor as yourself.'" [20] "I've obeyed all these commandments," the young man replied. "What else must I do?" [21] Jesus told him, "If you want to be perfect, go and sell all your possessions and give the money to the poor, and you will have treasure in heaven. Then come, follow me." [22] But when the young man heard this, he went away sad, for he had many possessions. [23] Then Jesus said to his disciples, "I tell you the truth, it is very hard for a rich person to enter the Kingdom of Heaven. [24] I'll say it again—it is easier for a camel to go through the eye of a needle than for a rich person to enter the Kingdom of God!" [25] The disciples were astounded. "Then who in the world can be saved?" they asked. [26] Jesus looked at them intently and said, "Humanly speaking, it is impossible. But with God everything is possible." [27] Then Peter said to him, "We've given up everything to follow you. What will we get?" [28] Jesus replied, "I assure you that when the world is made new and the Son of Man sits upon his glorious throne, you who have been my followers will also sit on twelve thrones, judging the twelve tribes of Israel. [29] And everyone who has given up houses or brothers or sisters or father or mother or children or property, for my sake, will receive a hundred times as much in return and will inherit eternal life. [30] But many who are the greatest now will be least important then, and those who seem least important now will be the greatest then.

20

PARABLE OF THE VINEYARD WORKERS

[1] "For the Kingdom of Heaven is like the landowner who went out early one morning to hire workers for his vineyard. [2] He agreed to pay the normal daily wage and sent them out to work. [3] "At nine o'clock in the morning he was passing through the marketplace and saw some people standing around doing nothing. [4] So he hired them, telling them he would pay them whatever was right at the end of the day. [5] So they went to work in the vineyard. At noon and again at three o'clock he did the same thing. [6] "At five o'clock that afternoon he was in town again and saw some more people standing around. He asked them, 'Why haven't you been working today?' [7] "They replied, 'Because no one hired us.' "The landowner told them, 'Then go out and join the others in my vineyard.' [8] "That evening he told the foreman to call the workers in and pay them, beginning with the last workers first. [9] When those hired at five o'clock were paid, each received a full day's wage. [10] When those hired first came to get their pay, they assumed they would receive more. But they, too, were paid a day's wage. [11] When they received their pay, they protested to the owner, [12] 'Those people worked only one hour, and yet you've paid them just as much as you paid us who worked all day in the scorching heat.' [13] "He answered one of them, 'Friend, I haven't been unfair! Didn't you agree to work all day for the usual wage? [14] Take your money and go. I wanted to pay this last worker the same as you. [15] Is it against the law for me to do what I want with my money? Should you be jealous because I am kind to others?' [16] "So those who are last now will be first then, and those who are first will be last."

JESUS AGAIN PREDICTS HIS DEATH

[17] As Jesus was going up to Jerusalem, he took the twelve disciples aside privately and told them what was going to happen to him. [18] "Listen," he said, "we're going up to Jerusalem, where the Son of Man will be betrayed to the leading priests and the teachers of religious law. They will sentence him to die. [19] Then they will hand him over to the Romans to be mocked, flogged with a whip, and crucified. But on the third day he will be raised from the dead."

JESUS TEACHES ABOUT SERVING OTHERS

[20] Then the mother of James and John, the sons of Zebedee, came to Jesus with her sons. She knelt respectfully to ask a favor. [21] "What is your request?" he asked. She replied, "In your Kingdom, please let my two sons sit in places of honor next to you, one on your right and the other on your left." [22] But Jesus answered by saying to them, "You don't know what you are asking! Are you able to drink from the bitter cup of suffering I am about to drink?" "Oh yes," they replied, "we are able!" [23] Jesus told them, "You will indeed drink from my bitter cup. But I have no right to say who will sit on my right or my left. My Father has prepared those places for the ones he has chosen." [24] When the ten other disciples heard what James and John had asked, they were indignant. [25] But Jesus called them together and said, "You know that the rulers in this world lord it over their people, and officials flaunt their authority over those under them. [26] But among you it will be different. Whoever wants to be a leader among you must be your servant, [27] and whoever wants to be first among you must become your slave. [28] For even the Son of Man came not to be served but to serve others and to give his life as a ransom for many."

JESUS HEALS TWO BLIND MEN

[29] As Jesus and the disciples left the town of Jericho, a large crowd followed behind. [30] Two blind men were sitting beside the road. When they heard that Jesus was coming that way, they began shouting, "Lord, Son of David, have mercy on us!" [31] "Be quiet!" the crowd yelled at them. But they only shouted louder, "Lord, Son of David, have mercy on us!" [32] When Jesus heard them, he stopped and called, "What do you want me to do for you?" [33] "Lord," they said, "we want to see!" [34] Jesus felt sorry for them and touched their eyes. Instantly they could see! Then they followed him.

21

JESUS' TRIUMPHANT ENTRY

¹ As Jesus and the disciples approached Jerusalem, they came to the town of Bethphage on the Mount of Olives. Jesus sent two of them on ahead. ² "Go into the village over there," he said. "As soon as you enter it, you will see a donkey tied there, with its colt beside it. Untie them and bring them to me. ³ If anyone asks what you are doing, just say, 'The Lord needs them,' and he will immediately let you take them." ⁴ This took place to fulfill the prophecy that said, ⁵ "Tell the people of Jerusalem, 'Look, your King is coming to you. He is humble, riding on a donkey—riding on a donkey's colt.'" ⁶ The two disciples did as Jesus commanded. ⁷ They brought the donkey and the colt to him and threw their garments over the colt, and he sat on it. ⁸ Most of the crowd spread their garments on the road ahead of him, and others cut branches from the trees and spread them on the road. ⁹ Jesus was in the center of the procession, and the people all around him were shouting, "Praise God for the Son of David! Blessings on the one who comes in the name of the Lord! Praise God in highest heaven!" ¹⁰ The entire city of Jerusalem was in an uproar as he entered. "Who is this?" they asked. ¹¹ And the crowds replied, "It's Jesus, the prophet from Nazareth in Galilee."

JESUS CLEARS THE TEMPLE

[12] Jesus entered the Temple and began to drive out all the people buying and selling animals for sacrifice. He knocked over the tables of the money changers and the chairs of those selling doves. [13] He said to them, "The Scriptures declare, 'My Temple will be called a house of prayer,' but you have turned it into a den of thieves!" [14] The blind and the lame came to him in the Temple, and he healed them. [15] The leading priests and the teachers of religious law saw these wonderful miracles and heard even the children in the Temple shouting, "Praise God for the Son of David." But the leaders were indignant. [16] They asked Jesus, "Do you hear what these children are saying?" "Yes," Jesus replied. "Haven't you ever read the Scriptures? For they say, 'You have taught children and infants to give you praise.'" [17] Then he returned to Bethany, where he stayed overnight.

JESUS CURSES THE FIG TREE

[18] In the morning, as Jesus was returning to Jerusalem, he was hungry, [19] and he noticed a fig tree beside the road. He went over to see if there were any figs, but there were only leaves. Then he said to it, "May you never bear fruit again!" And immediately the fig tree withered up. [20] The disciples were amazed when they saw this and asked, "How did the fig tree wither so quickly?" [21] Then Jesus told them, "I tell you the truth, if you have faith and don't doubt, you can do things like this and much more. You can even say to this mountain, 'May you be lifted up and thrown into the sea,' and it will happen. [22] You can pray for anything, and if you have faith, you will receive it."

THE AUTHORITY OF JESUS CHALLENGED

[23] When Jesus returned to the Temple and began teaching, the leading priests and elders came up to him. They demanded, "By what authority are you doing all these things? Who gave you the right?" [24] "I'll tell you by what authority I do these things if you answer one question," Jesus replied. [25] "Did John's authority to baptize come from heaven, or was it merely human?" They talked it over among themselves. "If we say it was from heaven, he will ask us why we didn't believe John. [26] But if we say it was merely human, we'll be mobbed because the people believe John was a prophet." [27] So they finally replied, "We don't know." And Jesus responded, "Then I won't tell you by what authority I do these things.

CHAPTER 21

ALABASTER | GOSPEL OF MATTHEW

PARABLE OF THE TWO SONS

[28] "But what do you think about this? A man with two sons told the older boy, 'Son, go out and work in the vineyard today.' [29] The son answered, 'No, I won't go,' but later he changed his mind and went anyway. [30] Then the father told the other son, 'You go,' and he said, 'Yes, sir, I will.' But he didn't go. [31] "Which of the two obeyed his father?" They replied, "The first." Then Jesus explained his meaning: "I tell you the truth, corrupt tax collectors and prostitutes will get into the Kingdom of God before you do. [32] For John the Baptist came and showed you the right way to live, but you didn't believe him, while tax collectors and prostitutes did. And even when you saw this happening, you refused to believe him and repent of your sins.

PARABLE OF THE EVIL FARMERS

[33] "Now listen to another story. A certain landowner planted a vineyard, built a wall around it, dug a pit for pressing out the grape juice, and built a lookout tower. Then he leased the vineyard to tenant farmers and moved to another country. [34] At the time of the grape harvest, he sent his servants to collect his share of the crop. [35] But the farmers grabbed his servants, beat one, killed one, and stoned another. [36] So the landowner sent a larger group of his servants to collect for him, but the results were the same. [37] "Finally, the owner sent his son, thinking, 'Surely they will respect my son.' [38] "But when the tenant farmers saw his son coming, they said to one another, 'Here comes the heir to this estate. Come on, let's kill him and get the estate for ourselves!' [39] So they grabbed him, dragged him out of the vineyard, and murdered him. [40] "When the owner of the vineyard returns," Jesus asked, "what do you think he will do to those farmers?" [41] The religious leaders replied, "He will put the wicked men to a horrible death and lease the vineyard to others who will give him his share of the crop after each harvest." [42] Then Jesus asked them, "Didn't you ever read this in the Scriptures? 'The stone that the builders rejected has now become the cornerstone. This is the Lord's doing, and it is wonderful to see.' [43] I tell you, the Kingdom of God will be taken away from you and given to a nation that will produce the proper fruit. [44] Anyone who stumbles over that stone will be broken to pieces, and it will crush anyone it falls on." [45] When the leading priests and Pharisees heard this parable, they realized he was telling the story against them—they were the wicked farmers. [46] They wanted to arrest him, but they were afraid of the crowds, who considered Jesus to be a prophet.

ALABASTER | GOSPEL OF MATTHEW

22

PARABLE OF THE GREAT FEAST

[1] Jesus also told them other parables. He said, [2] "The Kingdom of Heaven can be illustrated by the story of a king who prepared a great wedding feast for his son. [3] When the banquet was ready, he sent his servants to notify those who were invited. But they all refused to come! [4] "So he sent other servants to tell them, 'The feast has been prepared. The bulls and fattened cattle have been killed, and everything is ready. Come to the banquet!' [5] But the guests he had invited ignored them and went their own way, one to his farm, another to his business. [6] Others seized his messengers and insulted them and killed them. [7] "The king was furious, and he sent out his army to destroy the murderers and burn their town. [8] And he said to his servants, 'The wedding feast is ready, and the guests I invited aren't worthy of the honor. [9] Now go out to the street corners and invite everyone you see.' [10] So the servants brought in everyone they could find, good and bad alike, and the banquet hall was filled with guests. [11] "But when the king came in to meet the guests, he noticed a man who wasn't wearing the proper clothes for a wedding. [12] 'Friend,' he asked, 'how is it that you are here without wedding clothes?' But the man had no reply. [13] Then the king said to his aides, 'Bind his hands and feet and throw him into the outer darkness, where there will be weeping and gnashing of teeth.' [14] "For many are called, but few are chosen."

TAXES FOR CAESAR

[15] Then the Pharisees met together to plot how to trap Jesus into saying something for which he could be arrested. [16] They sent some of their disciples, along with the supporters of Herod, to meet with him. "Teacher," they said, "we know how honest you are. You teach the way of God truthfully. You are impartial and don't play favorites. [17] Now tell us what you think about this: Is it right to pay taxes to Caesar or not?" [18] But Jesus knew their evil motives. "You hypocrites!" he said. "Why are you trying to trap me? [19] Here, show me the coin used for the tax." When they handed him a Roman coin, [20] he asked, "Whose picture and title are stamped on it?" [21] "Caesar's," they replied. "Well, then," he said, "give to Caesar what belongs to Caesar, and give to God what belongs to God." [22] His reply amazed them, and they went away.

DISCUSSION ABOUT RESURRECTION

[23] That same day Jesus was approached by some Sadducees—religious leaders who say there is no resurrection from the dead. They posed this question: [24] "Teacher, Moses said, 'If a man dies without children, his brother should marry the widow and have a child who will carry on the brother's name.' [25] Well, suppose there were seven brothers. The oldest one married and then died without children, so his brother married the widow. [26] But the second brother also died, and the third brother married her. This continued with all seven of them. [27] Last of all, the woman also died. [28] So tell us, whose wife will she be in the resurrection? For all seven were married to her." [29] Jesus replied, "Your mistake is that you don't know the Scriptures, and you don't know the power of God. [30] For when the dead rise, they will neither marry nor be given in marriage. In this respect they will be like the angels in heaven. [31] "But now, as to whether there will be a resurrection of the dead—haven't you ever read about this in the Scriptures? Long after Abraham, Isaac, and Jacob had died, God said, [32] 'I am the God of Abraham, the God of Isaac, and the God of Jacob.' So he is the God of the living, not the dead." [33] When the crowds heard him, they were astounded at his teaching.

ALABASTER | GOSPEL OF MATTHEW

THE MOST IMPORTANT COMMANDMENT

[34] But when the Pharisees heard that he had silenced the Sadducees with his reply, they met together to question him again. [35] One of them, an expert in religious law, tried to trap him with this question: [36] "Teacher, which is the most important commandment in the law of Moses?" [37] Jesus replied, "'You must love the Lord your God with all your heart, all your soul, and all your mind.' [38] This is the first and greatest commandment. [39] A second is equally important: 'Love your neighbor as yourself.' [40] The entire law and all the demands of the prophets are based on these two commandments."

WHOSE SON IS THE MESSIAH?

[41] Then, surrounded by the Pharisees, Jesus asked them a question: [42] "What do you think about the Messiah? Whose son is he?" They replied, "He is the son of David." [43] Jesus responded, "Then why does David, speaking under the inspiration of the Spirit, call the Messiah 'my Lord'? For David said, [44] 'The Lord said to my Lord, Sit in the place of honor at my right hand until I humble your enemies beneath your feet.' [45] Since David called the Messiah 'my Lord,' how can the Messiah be his son?" [46] No one could answer him. And after that, no one dared to ask him any more questions.

ALABASTER | GOSPEL OF MATTHEW

23

JESUS CRITICIZES THE RELIGOUS LEADERS

[1] Then Jesus said to the crowds and to his disciples, [2] "The teachers of religious law and the Pharisees are the official interpreters of the law of Moses. [3] So practice and obey whatever they tell you, but don't follow their example. For they don't practice what they teach. [4] They crush people with unbearable religious demands and never lift a finger to ease the burden. [5] "Everything they do is for show. On their arms they wear extra wide prayer boxes with Scripture verses inside, and they wear robes with extra long tassels. [6] And they love to sit at the head table at banquets and in the seats of honor in the synagogues. [7] They love to receive respectful greetings as they walk in the marketplaces, and to be called 'Rabbi.' [8] "Don't let anyone call you 'Rabbi,' for you have only one teacher, and all of you are equal as brothers and sisters. [9] And don't address anyone here on earth as 'Father,' for only God in heaven is your Father. [10] And don't let anyone call you 'Teacher,' for you have only one teacher, the Messiah. [11] The greatest among you must be a servant. [12] But those who exalt themselves will be humbled, and those who humble themselves will be exalted. [13] "What sorrow awaits you teachers of religious law and you Pharisees. Hypocrites! For you shut the door of the Kingdom of Heaven in people's faces. You won't go in yourselves, and you don't let others enter either. [15] "What sorrow awaits you teachers of religious law and you Pharisees. Hypocrites! For you cross land and sea to make one convert, and then you turn that person into twice the child of hell you yourselves are! [16] "Blind guides! What sorrow awaits you! For you say that it means nothing to swear 'by God's Temple,' but that it is binding to swear 'by the gold in the Temple.' [17] Blind fools! Which is more important—the gold or the Temple that makes the gold sacred? [18] And you say that to swear 'by the altar' is not binding, but to swear 'by the gifts on the altar' is binding. [19] How blind! For which is more important—the gift on the altar or the altar that makes the gift sacred? [20] When you swear 'by the altar,' you are swearing by it and by everything on it. [21] And when you swear 'by the Temple,' you are swearing by it and by God, who lives in it. [22] And when you swear 'by heaven,' you are swearing by the throne of God and by God, who sits on the throne. [23] "What sorrow awaits you teachers of religious law and you Pharisees. Hypocrites! For you are careful to tithe even the tiniest income from your herb gardens, but you ignore the more important aspects of the law—justice, mercy, and faith. You should tithe, yes, but do not neglect the more important things. [24] Blind guides! You strain your water so you won't accidentally swallow a gnat, but you swallow a camel! [25] "What sorrow awaits you teachers of religious law

and you Pharisees. Hypocrites! For you are so careful to clean the outside of the cup and the dish, but inside you are filthy—full of greed and self-indulgence! [26] You blind Pharisee! First wash the inside of the cup and the dish, and then the outside will become clean, too. [27] "What sorrow awaits you teachers of religious law and you Pharisees. Hypocrites! For you are like whitewashed tombs—beautiful on the outside but filled on the inside with dead people's bones and all sorts of impurity. [28] Outwardly you look like righteous people, but inwardly your hearts are filled with hypocrisy and lawlessness. [29] "What sorrow awaits you teachers of religious law and you Pharisees. Hypocrites! For you build tombs for the prophets your ancestors killed, and you decorate the monuments of the godly people your ancestors destroyed. [30] Then you say, 'If we had lived in the days of our ancestors, we would never have joined them in killing the prophets.' [31] "But in saying that, you testify against yourselves that you are indeed the descendants of those who murdered the prophets. [32] Go ahead and finish what your ancestors started. [33] Snakes! Sons of vipers! How will you escape the judgment of hell? [34] "Therefore, I am sending you prophets and wise men and teachers of religious law. But you will kill some by crucifixion, and you will flog others with whips in your synagogues, chasing them from city to city. [35] As a result, you will be held responsible for the murder of all godly people of all time—from the murder of righteous Abel to the murder of Zechariah son of Berekiah, whom you killed in the Temple between the sanctuary and the altar. [36] I tell you the truth, this judgment will fall on this very generation.

JESUS GRIEVES OVER JERUSALEM

[37] "O Jerusalem, Jerusalem, the city that kills the prophets and stones God's messengers! How often I have wanted to gather your children together as a hen protects her chicks beneath her wings, but you wouldn't let me. [38] And now, look, your house is abandoned and desolate. [39] For I tell you this, you will never see me again until you say, 'Blessings on the one who comes in the name of the Lord!'"

24

JESUS SPEAKS ABOUT THE FUTURE

¹ As Jesus was leaving the Temple grounds, his disciples pointed out to him the various Temple buildings. ² But he responded, "Do you see all these buildings? I tell you the truth, they will be completely demolished. Not one stone will be left on top of another!" ³ Later, Jesus sat on the Mount of Olives. His disciples came to him privately and said, "Tell us, when will all this happen? What sign will signal your return and the end of the world?" ⁴ Jesus told them, "Don't let anyone mislead you, ⁵ for many will come in my name, claiming, 'I am the Messiah.' They will deceive many. ⁶ And you will hear of wars and threats of wars, but don't panic. Yes, these things must take place, but the end won't follow immediately. ⁷ Nation will go to war against nation, and kingdom against kingdom. There will be famines and earthquakes in many parts of the world. ⁸ But all this is only the first of the birth pains, with more to come. ⁹ "Then you will be arrested, persecuted, and killed. You will be hated all over the world because you are my followers.¹⁰ And many will turn away from me and betray and hate each other. ¹¹ And many false prophets will appear and will deceive many people. ¹² Sin will be rampant everywhere, and the love of many will grow cold. ¹³ But the one who endures to the end will be saved. ¹⁴ And the Good News about the Kingdom will be preached throughout the whole world, so that all nations will hear it; and then the end will come. ¹⁵ "The day is coming when you will see what Daniel the prophet spoke about—the sacrilegious object that causes desecration standing in the Holy Place." (Reader, pay attention!) ¹⁶ "Then those in Judea must flee to the hills. ¹⁷ A person out on the deck of a roof must not go down into the house to pack. ¹⁸ A person out in the field must not return even to get a coat. ¹⁹ How terrible it will be for pregnant women and for nursing mothers in those days. ²⁰ And pray that your flight will not be in winter or on the Sabbath. ²¹ For there will be greater anguish than at any time since the world began. And it will never be so great again. ²² In fact, unless that time of calamity is shortened, not a single person will survive. But it will be short-

ened for the sake of God's chosen ones. 23 "Then if anyone tells you, 'Look, here is the Messiah,' or 'There he is,' don't believe it. 24 For false messiahs and false prophets will rise up and perform great signs and wonders so as to deceive, if possible, even God's chosen ones. 25 See, I have warned you about this ahead of time. 26 "So if someone tells you, 'Look, the Messiah is out in the desert,' don't bother to go and look. Or, 'Look, he is hiding here,' don't believe it! 27 For as the lightning flashes in the east and shines to the west, so it will be when the Son of Man comes. 28 Just as the gathering of vultures shows there is a carcass nearby, so these signs indicate that the end is near. 29 "Immediately after the anguish of those days, the sun will be darkened, the moon will give no light, the stars will fall from the sky, and the powers in the heavens will be shaken. 30 And then at last, the sign that the Son of Man is coming will appear in the heavens, and there will be deep mourning among all the peoples of the earth. And they will see the Son of Man coming on the clouds of heaven with power and great glory. 31 And he will send out his angels with the mighty blast of a trumpet, and they will gather his chosen ones from all over the world—from the farthest ends of the earth and heaven. 32 "Now learn a lesson from the fig tree. When its branches bud and its leaves begin to sprout, you know that summer is near. 33 In the same way, when you see all these things, you can know his return is very near, right at the door. 34 I tell you the truth, this generation will not pass from the scene until all these things take place. 35 Heaven and earth will disappear, but my words will never disappear. 36 "However, no one knows the day or hour when these things will happen, not even the angels in heaven or the Son himself. Only the Father knows. 37 "When the Son of Man returns, it will be like it was in Noah's day. 38 In those days before the flood, the people were enjoying banquets and parties and weddings right up to the time Noah entered his boat. 39 People didn't realize what was going to happen until the flood came and swept them all away. That is the way it will be when the Son of Man comes. 40 "Two men will be working together in the field; one will be taken, the other left. 41 Two women will be grinding flour at the mill; one will be taken, the other left. 42 "So you, too, must keep watch! For you don't know what day your Lord is coming. 43 Understand this: If a homeowner knew exactly when a burglar was coming, he would keep watch and not permit his house to be broken into. 44 You also must be ready all the time, for the Son of Man will come when least expected. 45 "A faithful, sensible servant is one to whom the master can give the responsibility of managing his other household servants and feeding them. 46 If the master returns and finds that the servant has done a good job, there will be a reward. 47 I tell you the truth, the master will put that servant in charge of all he owns. 48 But what if the servant is evil and thinks, 'My master won't be back for a while,' 49 and he begins beating the other servants, partying, and getting drunk? 50 The master will return unannounced and unexpected, 51 and he will cut the servant to pieces and assign him a place with the hypocrites. In that place there will be weeping and gnashing of teeth.

25

PARABLE OF THE TEN BRIDESMAIDS

[1] "Then the Kingdom of Heaven will be like ten bridesmaids who took their lamps and went to meet the bridegroom. [2] Five of them were foolish, and five were wise. [3] The five who were foolish didn't take enough olive oil for their lamps, [4] but the other five were wise enough to take along extra oil. [5] When the bridegroom was delayed, they all became drowsy and fell asleep. [6] "At midnight they were roused by the shout, 'Look, the bridegroom is coming! Come out and meet him!' [7] "All the bridesmaids got up and prepared their lamps. [8] Then the five foolish ones asked the others, 'Please give us some of your oil because our lamps are going out.' [9] "But the others replied, 'We don't have enough for all of us. Go to a shop and buy some for yourselves.' [10] "But while they were gone to buy oil, the bridegroom came. Then those who were ready went in with him to the marriage feast, and the door was locked. [11] Later, when the other five bridesmaids returned, they stood outside, calling, 'Lord! Lord! Open the door for us!' [12] "But he called back, 'Believe me, I don't know you!' [13] "So you, too, must keep watch! For you do not know the day or hour of my return.

PARABLE OF THE THREE SERVANTS

[14] "Again, the Kingdom of Heaven can be illustrated by the story of a man going on a long trip. He called together his servants and entrusted his money to them while he was gone. [15] He gave five bags of silver to one, two bags of silver to another, and one bag of silver to the last—dividing it in proportion to their abilities. He then left on his trip. [16] "The servant who received the five bags of silver began to invest the money and earned five more. [17] The servant with two bags of silver also went to work and earned two more. [18] But the servant who received the one bag of silver dug a hole in the ground and hid the master's money. [19] "After a long time their master returned from his trip and called them to give an account of how they had used his money. [20] The servant to whom he had entrusted the five bags of silver came forward with five more and said, 'Master, you gave me five bags of silver to invest, and I have earned five more.' [21] "The master was full of praise. 'Well done, my good and faithful servant. You have been faithful in handling this small amount, so now I will give you many more responsibilities. Let's celebrate together!' [22] "The servant who had received the two bags of silver came forward and said, 'Master, you gave me two bags of silver to invest, and I have earned two more.' [23] "The master said, 'Well done, my good and faithful servant. You have been faithful in handling this small amount, so now I will give you many more responsibilities. Let's celebrate together!' [24] "Then the servant with the one bag of silver came and said, 'Master, I knew you were a harsh man, harvesting crops you didn't plant and gathering crops you didn't cultivate. [25] I was afraid I would lose your money, so I hid it in the earth. Look, here is your money back.' [26] "But the master replied, 'You wicked and lazy servant! If you knew I harvested crops I didn't plant and gathered crops I didn't cultivate, [27] why didn't you deposit my money in the bank? At least I could have gotten some interest on it.' [28] "Then he ordered, 'Take the money from this servant, and give it to the one with the ten bags of silver. [29] To those who use well what they are given, even more will be given, and they will have an abundance. But from those who do nothing, even what little they have will be taken away. [30] Now throw this useless servant into outer darkness, where there will be weeping and gnashing of teeth.'

THE FINAL JUDGMENT

[31] "But when the Son of Man comes in his glory, and all the angels with him, then he will sit upon his glorious throne. [32] All the nations will be gathered in his presence, and he will separate the people as a shepherd separates the sheep from the goats. [33] He will place the sheep at his right hand and the goats at his left. [34] "Then the King will say to those on his right, 'Come, you who are blessed by my Father, inherit the Kingdom prepared for you from the creation of the world. [35] For I was hungry, and you fed me. I was thirsty, and you gave me a drink. I was a stranger, and you invited me into your home. [36] I was naked, and you gave me clothing. I was sick, and you cared for me. I was in prison, and you visited me.' [37] "Then these righteous ones will reply, 'Lord, when did we ever see you hungry and feed you? Or thirsty and give you something to drink? [38] Or a stranger and show you hospitality? Or naked and give you clothing? [39] When did we ever see you sick or in prison and visit you?' [40] "And the King will say, 'I tell you the truth, when you did it to one of the least of these my brothers and sisters, you were doing it to me!' [41] "Then the King will turn to those on the left and say, 'Away with you, you cursed ones, into the eternal fire prepared for the devil and his demons. [42] For I was hungry, and you didn't feed me. I was thirsty, and you didn't give me a drink. [43] I was a stranger, and you didn't invite me into your home. I was naked, and you didn't give me clothing. I was sick and in prison, and you didn't visit me.' [44] "Then they will reply, 'Lord, when did we ever see you hungry or thirsty or a stranger or naked or sick or in prison, and not help you?' [45] "And he will answer, 'I tell you the truth, when you refused to help the least of these my brothers and sisters, you were refusing to help me.' [46] "And they will go away into eternal punishment, but the righteous will go into eternal life."

26

THE PLOT TO KILL JESUS

[1] When Jesus had finished saying all these things, he said to his disciples, [2] "As you know, Passover begins in two days, and the Son of Man will be handed over to be crucified." [3] At that same time the leading priests and elders were meeting at the residence of Caiaphas, the high priest, [4] plotting how to capture Jesus secretly and kill him. [5] "But not during the Passover celebration," they agreed, "or the people may riot."

JESUS ANOINTED AT BETHANY

[6] Meanwhile, Jesus was in Bethany at the home of Simon, a man who had previously had leprosy. [7] While he was eating, a woman came in with a beautiful alabaster jar of expensive perfume and poured it over his head. [8] The disciples were indignant when they saw this. "What a waste!" they said. [9] "It could have been sold for a high price and the money given to the poor." [10] But Jesus, aware of this, replied, "Why criticize this woman for doing such a good thing to me? [11] You will always have the poor among you, but you will not always have me. [12] She has poured this perfume on me to prepare my body for burial. [13] I tell you the truth, wherever the Good News is preached throughout the world, this woman's deed will be remembered and discussed."

JUDAS AGREES TO BETRAY JESUS

[14] Then Judas Iscariot, one of the twelve disciples, went to the leading priests [15] and asked, "How much will you pay me to betray Jesus to you?" And they gave him thirty pieces of silver. [16] From that time on, Judas began looking for an opportunity to betray Jesus.

CHAPTER 26

THE LAST SUPPER

[17] On the first day of the Festival of Unleavened Bread, the disciples came to Jesus and asked, "Where do you want us to prepare the Passover meal for you?" [18] "As you go into the city," he told them, "you will see a certain man. Tell him, 'The Teacher says: My time has come, and I will eat the Passover meal with my disciples at your house.'" [19] So the disciples did as Jesus told them and prepared the Passover meal there. [20] When it was evening, Jesus sat down at the table with the Twelve. [21] While they were eating, he said, "I tell you the truth, one of you will betray me." [22] Greatly distressed, each one asked in turn, "Am I the one, Lord?" [23] He replied, "One of you who has just eaten from this bowl with me will betray me. [24] For the Son of Man must die, as the Scriptures declared long ago. But how terrible it will be for the one who betrays him. It would be far better for that man if he had never been born!" [25] Judas, the one who would betray him, also asked, "Rabbi, am I the one?" And Jesus told him, "You have said it." [26] As they were eating, Jesus took some bread and blessed it. Then he broke it in pieces and gave it to the disciples, saying, "Take this and eat it, for this is my body." [27] And he took a cup of wine and gave thanks to God for it. He gave it to them and said, "Each of you drink from it, [28] for this is my blood, which confirms the covenant between God and his people. It is poured out as a sacrifice to forgive the sins of many. [29] Mark my words—I will not drink wine again until the day I drink it new with you in my Father's Kingdom." [30] Then they sang a hymn and went out to the Mount of Olives.

JESUS PREDICTS PETER'S DENIAL

[31] On the way, Jesus told them, "Tonight all of you will desert me. For the Scriptures say, 'God will strike the Shepherd, and the sheep of the flock will be scattered.' [32] But after I have been raised from the dead, I will go ahead of you to Galilee and meet you there." [33] Peter declared, "Even if everyone else deserts you, I will never desert you." [34] Jesus replied, "I tell you the truth, Peter—this very night, before the rooster crows, you will deny three times that you even know me." [35] "No!" Peter insisted. "Even if I have to die with you, I will never deny you!" And all the other disciples vowed the same.

JESUS PRAYS IN GETHSEMANE

[36] Then Jesus went with them to the olive grove called Gethsemane, and he said, "Sit here while I go over there to pray." [37] He took Peter and Zebedee's two sons, James and John, and he became anguished and distressed. [38] He told them, "My soul is crushed with grief to the point of death. Stay here and keep watch with me." [39] He went on a little farther and bowed with his face to the ground, praying, "My Father! If it is possible, let this cup of suffering be taken away from me. Yet I want your will to be done, not mine." [40] Then he returned to the disciples and found them asleep. He said to Peter, "Couldn't you watch with me even one hour? [41] Keep watch and pray, so that you will not give in to temptation. For the spirit is willing, but the body is weak!" [42] Then Jesus left them a second time and prayed, "My Father! If this cup cannot be taken away unless I drink it, your will be done." [43] When he returned to them again, he found them sleeping, for they couldn't keep their eyes open. [44] So he went to pray a third time, saying the same things again. [45] Then he came to the disciples and said, "Go ahead and sleep. Have your rest. But look—the time has come. The Son of Man is betrayed into the hands of sinners. [46] Up, let's be going. Look, my betrayer is here!"

JESUS IS BETRAYED AND ARRESTED

[47] And even as Jesus said this, Judas, one of the twelve disciples, arrived with a crowd of men armed with swords and clubs. They had been sent by the leading priests and elders of the people. [48] The traitor, Judas, had given them a prearranged signal: "You will know which one to arrest when I greet him with a kiss." [49] So Judas came straight to Jesus. "Greetings, Rabbi!" he exclaimed and gave him the kiss. [50] Jesus said, "My friend, go ahead and do what you have come for." Then the others grabbed Jesus and arrested him. [51] But one of the men with Jesus pulled out his sword and struck the high priest's slave, slashing off his ear. [52] "Put away your sword," Jesus told him. "Those who use the sword will die by the sword. [53] Don't you realize that I could ask my Father for thousands of angels to protect us, and he would send them instantly? [54] But if I did, how would the Scriptures be fulfilled that describe what must happen now?" [55] Then Jesus said to the crowd, "Am I some dangerous revolutionary, that you come with swords and clubs to arrest me? Why didn't you arrest me in the Temple? I was there teaching every day. [56] But this is all happening to fulfill the words of the prophets as recorded in the Scriptures." At that point, all the disciples deserted him and fled.

JESUS BEFORE THE COUNCIL

[57] Then the people who had arrested Jesus led him to the home of Caiaphas, the high priest, where the teachers of religious law and the elders had gathered. [58] Meanwhile, Peter followed him at a distance and came to the high priest's courtyard. He went in and sat with the guards and waited to see how it would all end. [59] Inside, the leading priests and the entire high council were trying to find witnesses who would lie about Jesus, so they could put him to death. [60] But even though they found many who agreed to give false witness, they could not use anyone's testimony. Finally, two men came forward [61] who declared, "This man said, 'I am able to destroy the Temple of God and rebuild it in three days.'" [62] Then the high priest stood up and said to Jesus, "Well, aren't you going to answer these charges? What do you have to say for yourself?" [63] But Jesus remained silent. Then the high priest said to him, "I demand in the name of the living God—tell us if you are the Messiah, the Son of God." [64] Jesus replied, "You have said it. And in the future you will see the Son of Man seated in the place of power at God's right hand and coming on the clouds of heaven." [65] Then the high priest tore his clothing to show his horror and said, "Blasphemy! Why do we need other witnesses? You have all heard his blasphemy. [66] What is your verdict?" "Guilty!" they shouted. "He deserves to die!" [67] Then they began to spit in Jesus' face and beat him with their fists. And some slapped him, [68] jeering, "Prophesy to us, you Messiah! Who hit you that time?"

PETER DENIES JESUS

[69] Meanwhile, Peter was sitting outside in the courtyard. A servant girl came over and said to him, "You were one of those with Jesus the Galilean." [70] But Peter denied it in front of everyone. "I don't know what you're talking about," he said. [71] Later, out by the gate, another servant girl noticed him and said to those standing around, "This man was with Jesus of Nazareth." [72] Again Peter denied it, this time with an oath. "I don't even know the man," he said. [73] A little later some of the other bystanders came over to Peter and said, "You must be one of them; we can tell by your Galilean accent." [74] Peter swore, "A curse on me if I'm lying—I don't know the man!" And immediately the rooster crowed. [75] Suddenly, Jesus' words flashed through Peter's mind: "Before the rooster crows, you will deny three times that you even know me." And he went away, weeping bitterly.

CHAPTER 26

27

JUDAS HANGS HIMSELF

¹ Very early in the morning the leading priests and the elders of the people met again to lay plans for putting Jesus to death. ² Then they bound him, led him away, and took him to Pilate, the Roman governor. ³ When Judas, who had betrayed him, realized that Jesus had been condemned to die, he was filled with remorse. So he took the thirty pieces of silver back to the leading priests and the elders. ⁴ "I have sinned," he declared, "for I have betrayed an innocent man." "What do we care?" they retorted. "That's your problem." ⁵ Then Judas threw the silver coins down in the Temple and went out and hanged himself. ⁶ The leading priests picked up the coins. "It wouldn't be right to put this money in the Temple treasury," they said, "since it was payment for murder." ⁷ After some discussion they finally decided to buy the potter's field, and they made it into a cemetery for foreigners. ⁸ That is why the field is still called the Field of Blood. ⁹ This fulfilled the prophecy of Jeremiah that says, "They took the thirty pieces of silver—the price at which he was valued by the people of Israel, ¹⁰ and purchased the potter's field, as the Lord directed."

JESUS' TRIAL BEFORE PILATE

¹¹ Now Jesus was standing before Pilate, the Roman governor. "Are you the king of the Jews?" the governor asked him. Jesus replied, "You have said it." ¹² But when the leading priests and the elders made their accusations against him, Jesus remained silent. ¹³ "Don't you hear all these charges they are bringing against you?" Pilate demanded. ¹⁴ But Jesus made no response to any of the charges, much to the governor's surprise. ¹⁵ Now it was the governor's custom each year during the Passover celebration to release one prisoner to the crowd—anyone they wanted. ¹⁶ This year there was a notorious prisoner, a man named Barabbas. ¹⁷ As the crowds gathered before Pilate's house that morning, he asked them, "Which one do you want me to release to you—Barabbas, or Jesus who is called the Messiah?" ¹⁸ (He knew very well that the religious leaders had arrested Jesus out of envy.) ¹⁹ Just then, as Pilate was sitting on the judgment seat, his wife sent him this message: "Leave that innocent man alone. I suffered through a terrible nightmare about him last night." ²⁰ Meanwhile, the leading priests and the elders persuaded the crowd to ask for Barabbas to be released and for Jesus to be put to death. ²¹ So the governor asked again, "Which of these two do you want me to release to you?" The crowd shouted back, "Barabbas!" ²² Pilate responded, "Then what should I do with Jesus who is called the Messiah?" They shouted back, "Crucify him!" ²³ "Why?" Pilate demanded. "What crime has he committed?" But the mob roared even louder, "Crucify him!" ²⁴ Pilate saw that he wasn't getting anywhere and that a riot was developing. So he sent for a bowl of water and washed his hands before the crowd, saying, "I am innocent of this man's blood. The responsibility is yours!" ²⁵ And all the people yelled back, "We will take responsibility for his death—we and our children!" ²⁶ So Pilate released Barabbas to them. He ordered Jesus flogged with a lead-tipped whip, then turned him over to the Roman soldiers to be crucified.

CHAPTER 27

THE SOLDIERS MOCK JESUS

27 Some of the governor's soldiers took Jesus into their headquarters and called out the entire regiment. 28 They stripped him and put a scarlet robe on him. 29 They wove thorn branches into a crown and put it on his head, and they placed a reed stick in his right hand as a scepter. Then they knelt before him in mockery and taunted, "Hail! King of the Jews!" 30 And they spit on him and grabbed the stick and struck him on the head with it. 31 When they were finally tired of mocking him, they took off the robe and put his own clothes on him again. Then they led him away to be crucified.

THE CRUCIFIXION

32 Along the way, they came across a man named Simon, who was from Cyrene, and the soldiers forced him to carry Jesus' cross. 33 And they went out to a place called Golgotha (which means "Place of the Skull"). 34 The soldiers gave Jesus wine mixed with bitter gall, but when he had tasted it, he refused to drink it. 35 After they had nailed him to the cross, the soldiers gambled for his clothes by throwing dice. 36 Then they sat around and kept guard as he hung there. 37 A sign was fastened above Jesus' head, announcing the charge against him. It read: "This is Jesus, the King of the Jews." 38 Two revolutionaries were crucified with him, one on his right and one on his left. 39 The people passing by shouted abuse, shaking their heads in mockery. 40 "Look at you now!" they yelled at him. "You said you were going to destroy the Temple and rebuild it in three days. Well then, if you are the Son of God, save yourself and come down from the cross!" 41 The leading priests, the teachers of religious law, and the elders also mocked Jesus. 42 "He saved others," they scoffed, "but he can't save himself! So he is the King of Israel, is he? Let him come down from the cross right now, and we will believe in him! 43 He trusted God, so let God rescue him now if he wants him! For he said, 'I am the Son of God.'" 44 Even the revolutionaries who were crucified with him ridiculed him in the same way.

THE DEATH OF JESUS

45 At noon, darkness fell across the whole land until three o'clock. 46 At about three o'clock, Jesus called out with a loud voice, "Eli, Eli, lema sabachthani?"

which means "My God, my God, why have you abandoned me?" [47] Some of the bystanders misunderstood and thought he was calling for the prophet Elijah. [48] One of them ran and filled a sponge with sour wine, holding it up to him on a reed stick so he could drink. [49] But the rest said, "Wait! Let's see whether Elijah comes to save him." [50] Then Jesus shouted out again, and he released his spirit. [51] At that moment the curtain in the sanctuary of the Temple was torn in two, from top to bottom. The earth shook, rocks split apart, [52] and tombs opened. The bodies of many godly men and women who had died were raised from the dead. [53] They left the cemetery after Jesus' resurrection, went into the holy city of Jerusalem, and appeared to many people. [54] The Roman officer and the other soldiers at the crucifixion were terrified by the earthquake and all that had happened. They said, "This man truly was the Son of God!" [55] And many women who had come from Galilee with Jesus to care for him were watching from a distance. [56] Among them were Mary Magdalene, Mary (the mother of James and Joseph), and the mother of James and John, the sons of Zebedee.

THE BURIAL OF JESUS

[57] As evening approached, Joseph, a rich man from Arimathea who had become a follower of Jesus, [58] went to Pilate and asked for Jesus' body. And Pilate issued an order to release it to him. [59] Joseph took the body and wrapped it in a long sheet of clean linen cloth. [60] He placed it in his own new tomb, which had been carved out of the rock. Then he rolled a great stone across the entrance and left. [61] Both Mary Magdalene and the other Mary were sitting across from the tomb and watching.

THE GUARD AT THE TOMB

[62] The next day, on the Sabbath, the leading priests and Pharisees went to see Pilate. [63] They told him, "Sir, we remember what that deceiver once said while he was still alive: 'After three days I will rise from the dead.' [64] So we request that you seal the tomb until the third day. This will prevent his disciples from coming and stealing his body and then telling everyone he was raised from the dead! If that happens, we'll be worse off than we were at first." [65] Pilate replied, "Take guards and secure it the best you can." [66] So they sealed the tomb and posted guards to protect it.

ALABASTER | GOSPEL OF MATTHEW

28

THE RESURRECTION

[1] Early on Sunday morning, as the new day was dawning, Mary Magdalene and the other Mary went out to visit the tomb. [2] Suddenly there was a great earthquake! For an angel of the Lord came down from heaven, rolled aside the stone, and sat on it. [3] His face shone like lightning, and his clothing was as white as snow. [4] The guards shook with fear when they saw him, and they fell into a dead faint. [5] Then the angel spoke to the women. "Don't be afraid!" he said. "I know you are looking for Jesus, who was crucified. [6] He isn't here! He is risen from the dead, just as he said would happen. Come, see where his body was lying. [7] And now, go quickly and tell his disciples that he has risen from the dead, and he is going ahead of you to Galilee. You will see him there. Remember what I have told you." [8] The women ran quickly from the tomb. They were very frightened but also filled with great joy, and they rushed to give the disciples the angel's message. [9] And as they went, Jesus met them and greeted them. And they ran to him, grasped his feet, and worshiped him. [10] Then Jesus said to them, "Don't be afraid! Go tell my brothers to leave for Galilee, and they will see me there."

THE REPORT OF THE GUARD

[11] As the women were on their way, some of the guards went into the city and told the leading priests what had happened. [12] A meeting with the elders was called, and they decided to give the soldiers a large bribe. [13] They told the soldiers, "You must say, 'Jesus' disciples came during the night while we were sleeping, and they stole his body.' [14] If the governor hears about it, we'll stand up for you so you won't get in trouble." [15] So the guards accepted the bribe and said what they were told to say. Their story spread widely among the Jews, and they still tell it today.

THE GREAT COMMISSION

[16] Then the eleven disciples left for Galilee, going to the mountain where Jesus had told them to go. [17] When they saw him, they worshiped him—but some of them doubted! [18] Jesus came and told his disciples, "I have been given all authority in heaven and on earth. [19] Therefore, go and make disciples of all the nations, baptizing them in the name of the Father and the Son and the Holy Spirit. [20] Teach these new disciples to obey all the commands I have given you. And be sure of this: I am with you always, even to the end of the age."

CHAPTER 28

ALABASTER

BRYAN CHUNG
Editor in Chief & Creative Director

BRIAN CHUNG
Art Director & Business Operations

JOSEPHINE LAW
Lead Designer

IVAN BLANCO
Logo Designer

PATRON
William Pelster

PHOTOGRAPHERS
Jacob Chung

MODELS
GianCarlo Aguilar
Ayodale Braimah
Dani Chang
Daniel Davis
Kelechi Emetuche
Emily Greenfield
Alyssa Leonard
Scott Smith

CONTINUE THE CONVERSATION
www.alabasterco.com